G000152821

Michael Wesely
Time Works

Michael Wesely
Time Works

Mit einem Text von Jürgen Harten
Text by Jürgen Harten

3

Schirmer/Mosel

4

5

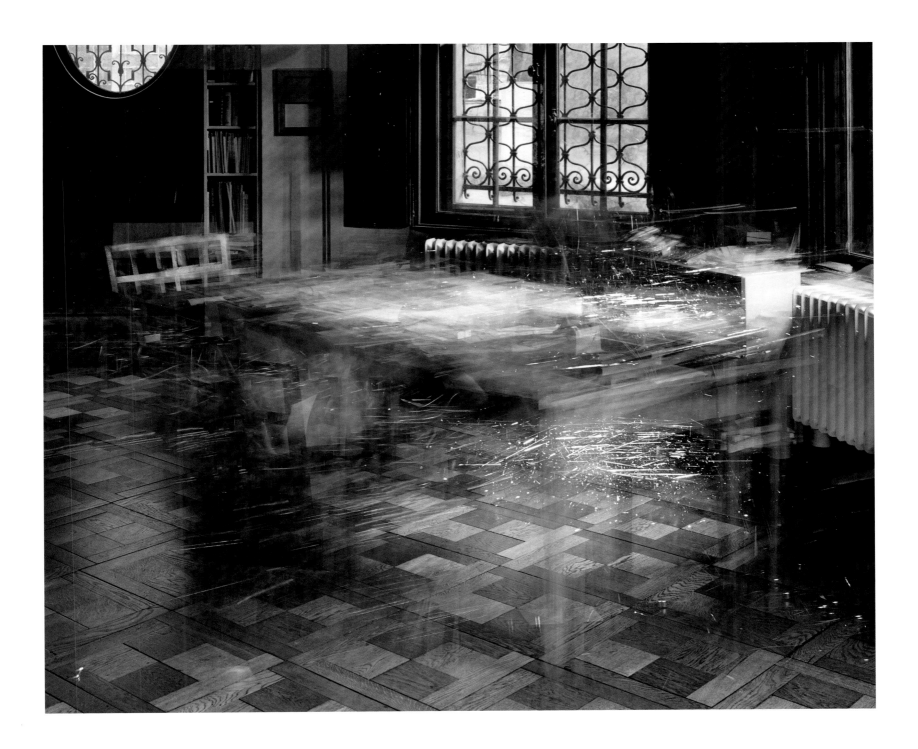

Büro Helmut Friedel, Lenbachhaus München (29.7.1996–29.7.1997)

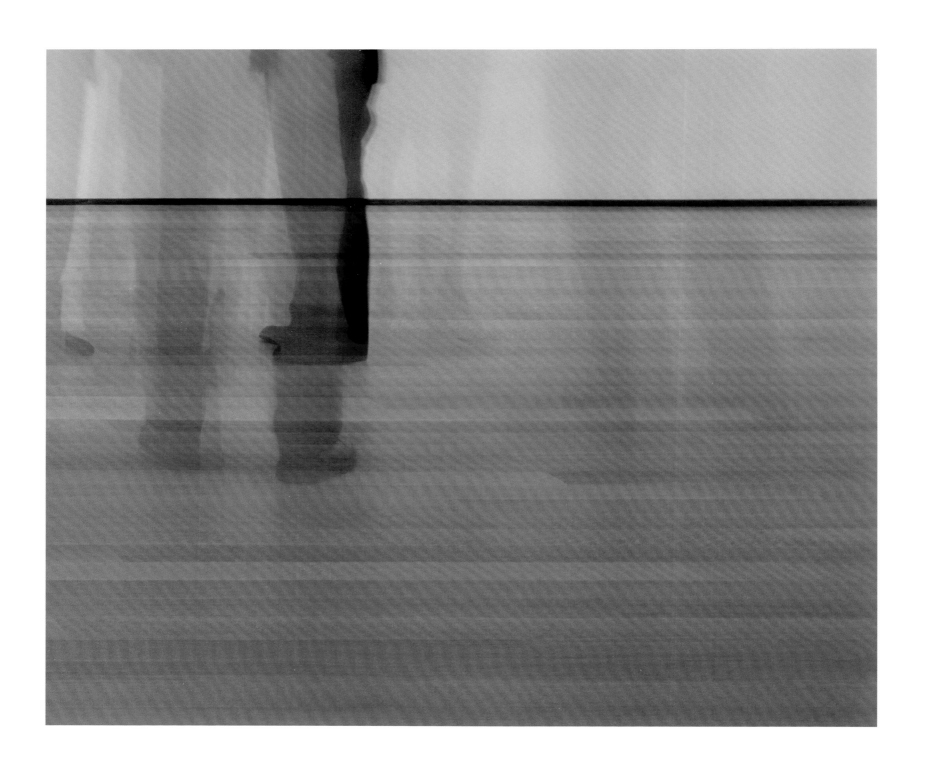

14

The Museum of Modern Art, New York (14.35–14.40 Uhr, 19.11.2004)

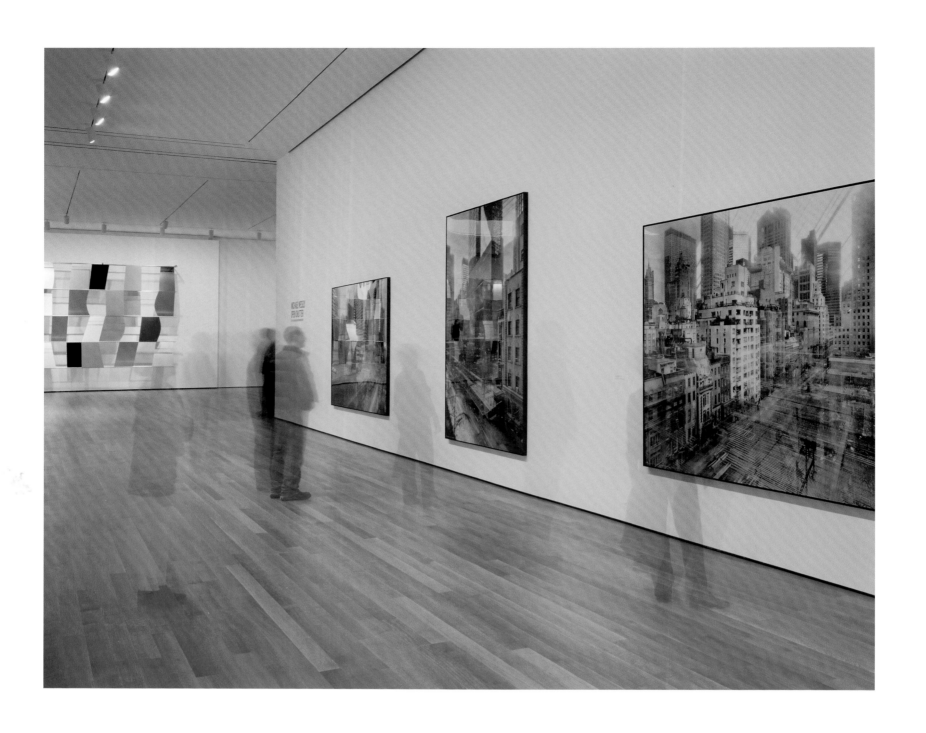

16

The Museum of Modern Art, New York (14.35–14.40 Uhr, 19.11.2004)

17

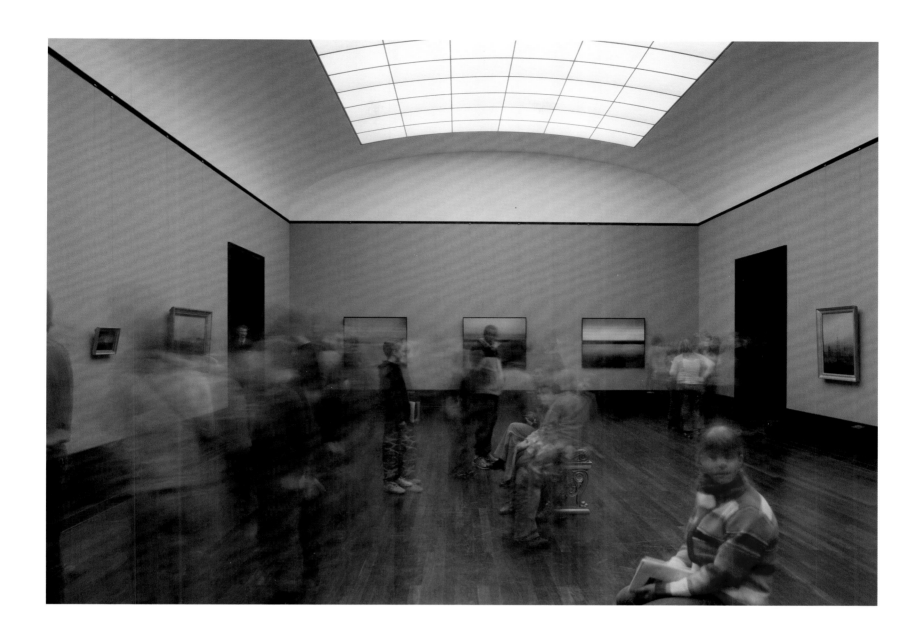

Alte Nationalgalerie Berlin (11.41–11.43 Uhr, 22.2.2006)

conceptual "synopsis", because he couldn't quite decide which of the experimental, pictorial modalities should become the one to pursue further. Thus, he went out into the world with nothing other than his camera and an unprejudiced eye for the world's infinite array of possibilities — "with nothing" meaning simply without a preconceived thematic angle or a particular way of looking, in the sense of a "school".

He was fundamentally sceptical about salient doctrines and conventions within photography. There was nothing more questionable to him than Cartier-Bresson's well-established, conventionally dogmatic "decisive moment" in photography, and nothing incensed him more than the blatancy of the minutely detailed, uniformly precise, supposedly realistic rendition that necessarily turned the viewer, as he maintained, into a voyeur. As if to prove that he would succeed in liberating himself radically from traditional ideas, he defined his starting point in purely experimental terms. He experimented with the functional changes of the camera obscura by means of aperture size and exposure time and thus induced a level of conceptuality into his photography, which in turn had an effect that could scarcely have been predicted.

Examples from this foundation phase include the conceptual objects in the series "Camera Controversa" from Salzburg in 1990, the striped pictures of the "Palazzi di Roma", which were taken using a slit-shaped aperture, or indeed the long time-lapse exposures from "Reisebilder" (Travel Photographs). Wesely's "Camera Controversa" should be understood as a box into which one can look from the rear (where the photo-sensitive plate would normally be situated in the camera obscura) and see distorted images of the respective, individual urban motifs on the surrounding, chemically coated plates. In art historical terms, the process may well be reminiscent of anamorphosis, although Wesely clearly cannot install a lens in the mind of the observer to rectify the distortion, that is to say, provide an in-focus image. In the "Roman Palaces" series, the slit-shaped aperture brings about a registering of the motif in the form of vertical, parallel, uneven, coloured stripes, i.e., of images that suggest something abstract and therefore differ enormously from the usual appearance one might expect, given their respective titles. At the same time, the use of the operational concept guarantees the reality content of the striped photographs. Nevertheless, anyone with local knowledge can, as Wesely readily stresses, recognise the palace in question by virtue of characteristic colour tonalities, despite the patent level of "abstraction".

The photographs on the topic of "travel time" are similarly imbued with conceptual reality. The time-lapse exposure of a particular railway platform matches the scheduled duration of a journey from the station of departure to a distant destination; moreover, it professes to capture everything that takes place on the platform during the elapsed period. What is meant here is not the course of the journey itself, rather the presentation of the journey as a metaphor for a period of time, which can be measured and conceptually anticipated. The anticipation may well be motivated, in concrete terms, by the desire to travel without necessarily being able to travel, for example, when an individual is denied the right to leave a country.

The camera sits out the period of time duly elapsing whilst the station backdrop — replete with all the vague traces of activity taking place there — provides visible proof of the reality of the imagined period of time.

The cited examples no longer feature in Wesely's current retrospective appraisal of his earlier creative phases. Instead, he has recourse today to some of the other photographs from the 1990s, which he took at art seminars and in art publishers' offices. Wesely set up his camera in places

Zusammenfassung (1989)

Zusammenfassung (1989), Ausschnitt

Die Antizipation mag konkret durch den Wunsch motiviert sein, reisen zu wollen, ohne reisen zu können, zum Beispiel wenn Menschen von Ausreiseverboten betroffen sind. Die Kamera wartet die Zeitspanne ab, während die Bahnhofskulisse mitsamt den vagen Spuren der dort abgelaufenen Vorgänge den sichtbaren Beweis für die Realität der vorgestellten Zeitspanne liefert.

Die genannten Beispiele kommen im gegenwärtigen Rückblick Weselys auf seine frühe Schaffensphase nicht mehr vor. Stattdessen beruft er sich heute auf einige andere Arbeiten aus den neunziger Jahren, die er auf Lehrveranstaltungen zur Kunst und in Kunstvermittlerbüros aufgenommen hat. Wesely stellte damals seine Kamera dort auf, wo Kunst studiert, wo über Kunst geredet und wo Kunst organisiert wurde. In dieser scheinbar simplen Tatsache steckt offensichtlich eine für die Radikalität seiner Haltung bezeichnende Herausforderung. Denn wie bei den *Reisebildern* entzieht sich das Motiv — hier nun die Kunst oder das, was man unter Kunst verstehen mag — der direkten Anschauung. Die Kamera erfasst nur, was es zu sehen gibt, wenn Menschen sich angeblich mit Kunst beschäftigen. Mit seiner scheinbar kunstlosen Fotografie fordert Wesely indirekt nicht nur so etwas wie die Idealität der Kunst heraus; als beteiligter Be-obachter konfrontiert er zugleich die eigene Arbeit mit dem Kunstanspruch. Er stellt die paradoxe Visualität der Langzeitbelichtung im Kunstkontext zur Diskussion. Die Langzeitbelichtung soll einerseits zwar ihren Gegenstand sichtbar in Erscheinung treten lassen, hat aber andererseits zur Folge, dass der ebenso deutliche wie momentane Anblick zugunsten einer zeitlich unter Umständen äußerst gedehnten, an Kontur verlierenden Aufzeichnung aufgegeben werden muss. Wie radikal diese Herausforderung ist, wird spätestens deutlich, sobald der Betrachter sich vor die Frage gestellt findet, was auf den Bildern denn tatsächlich zu sehen ist, sofern das Foto überhaupt noch mit der Vorstellung übereinstimmt, die er mit dem Motiv verbindet. Unter dieser Voraussetzung erscheint die Langzeitbelichtung als eine künstlerische Strategie, die versucht, etwas sichtbar zu machen, was sich normalerweise der Sichtbarkeit entzieht.

Die Aufnahme *Abendakt* erstreckt sich über zwei Stunden Aktstudium in der Münchner Akademie der Bildenden Künste. Alle Gegenstände sind, sofern sie nicht während der Aufnahme verschoben wurden, deutlich zu sehen: das Podium des Modells, die danebenstehenden Heizkörper, Hocker, Reißbretter, eine Staffelei. Von dem Aktmodell aber und den Studierenden sind nur Schemen erhalten, die deren zeitweilige Präsenz erahnen lassen, wobei die angeschnittene Andeutung der im Vordergrund sitzenden Studierenden dem Betrachter eine Position der Nähe zuweist. Das Bild vermittelt andeutungsweise einen Vorgang, dessen inhaltliche Bestimmung sich jedoch der Abbildung entzieht. Das Erlernen des Aktzeichnens kann man nicht sehen; objektiv werden bestenfalls die Bewegungen registriert, die beim Lernen vollzogen werden. Darüber hinaus lässt sich die Szene allerdings als Performance einer Überlieferung betrachten, derzufolge das Aktmodell beim Kunststudium die lebendige Natur repräsentiert. Wesely reagiert auf dieses kunstakademische Paradigma, indem er ihm mit dem Konzept einer temporären fotografischen Empfangsbestätigung des Lebendigen begegnet. In diesem Sinne kann *Abendakt* als eine Ikone der Kamerakunst Weselys von quasi selbstreferentieller Beschaffenheit aufgefasst werden.

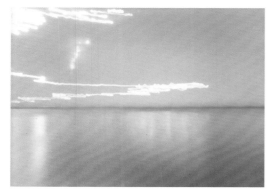
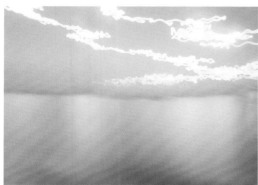

29

Manaus–Santarém
(17.00 Uhr, 29.7.– 8.00 Uhr, 31.7.2003)

Santarém–Belém
(17.00 Uhr, 1.8.– 7.00 Uhr, 3.8.2003)

Santa Monica Beach, Los Angeles
(18.41–19.01 Uhr, 21.2.2000)

Santa Monica Beach, Los Angeles
(18.11–18.31 Uhr, 21.2.2000)

where people study art, where art is talked about, and where art is *de facto* organised. There is a kind of challenge residing in this simple fact, which is characteristic of the radicality of Wesely's attitude. For in a similar way to the "travel photographs", the motif itself — in this case art, or whatever one might take art to be — eludes direct scrutiny. The camera can only take in what there is to see when people are allegedly preoccupied with the pursuit of art. With his apparently 'unarty' form of photography, Wesely is not only indirectly invoking something akin to the ideality of art; but as a participating observer, he is also simultaneously confronting his own work, with its inherent claim to be art. He puts up for discussion the paradoxical visuality of time-lapse photography in the context of art. On the one hand, time-lapse photography is supposed to allow its subject to remain visible, but on the other, it entails the necessary abandonment of an equally clear and momentary view in favour of a more diffuse registration of events, over what might be an extremely extended period of time. Exactly how radical this challenge is becomes clear, when, as a viewer, one finds oneself facing the question of the actual content of the photographs, inasmuch as the photograph coheres in any shape or form to the idea one might associate with the motif. Viewed in this way, time-lapse photography appears to be an artistic strategy aimed at rendering something visible that under normal circumstances eludes visibility.

The photograph "Abendakt" (Evening Life Study) covers a two-hour life drawing class at the Munich Academy of Fine Arts. All fixed objects, insofar as they were not repositioned during the session, are clearly visible: the model's podium, the adjacent radiators, stools, drawing boards, an easel. The only residual traces of the life model and the students are merely schematic, hinting at their temporary presence, whereby the suggestion of students sitting in the foreground gives the viewer a position of proximity. The photograph further suggests a process, the thematic determination of which once again eludes depiction. It is not possible to see how one learns life drawing; objectively speaking, it is possible at best to register the series of movements involved whilst one is learning. Over and above this, the scene can be construed as a performance of a tradition, in which the life model represents living nature in the context of the art school. Wesely reacts to this art historical paradigm by encountering it with the concept of a temporary photographic acknowledgement of the living. In this sense, "Abendakt" can be regarded as an almost self-referential icon of Wesely's camera art.

The series "Bilder und Wörter" (Images and Words) functions in a similar manner. As the titles indicate, the photographs were taken during two, approximately thirty-minute lectures held at the Munich Academy. It is neither possible to see the speaker, nor would it ever be possible to render visible the words being spoken; the camera has merely registered the behaviour of the audience during the lecture. One might speak of a behaviourist study, provided that whatever one was looking for would be stated somehow. However, as this is clearly not the case, it remains open as to whether the internal participation on the part of the audience in the lecture being delivered can ever make it to the surface of the image. In the truest sense of the word, the photographs of Helmut Friedel's and Kasper König's offices are both more overt and yet, at the same time, enigmatic. The camera was positioned with an open shutter for a whole year in front of the directors' desks in order to capture what was unfolding there. However, the resulting, glassily transparent, overall impression would be relatively meaningless to the viewer were it not for the title which helped both to localise the image and to charge it thematically. What is being

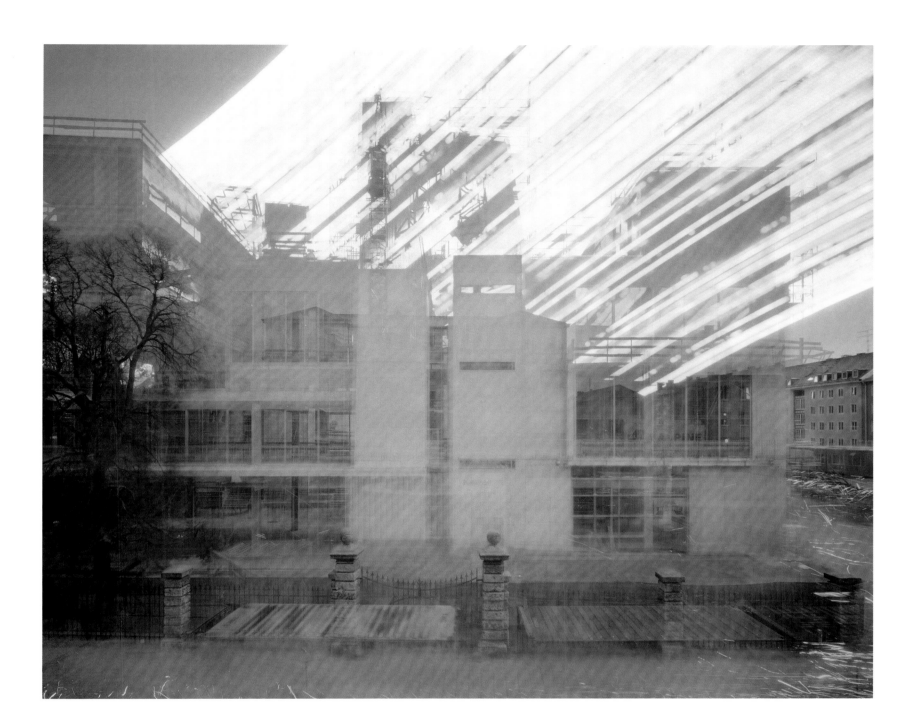

Akademie der Bildenen Künste, München (4.12.2003 – 26.10.2005)

Die Reihe *Bilder und Wörter* funktioniert ähnlich. Wie die Bildlegenden anzeigen, sind die Aufnahmen während zweier etwa halbstündiger Vorträge in der Münchner Akademie entstanden. Weder sieht man den Redner, noch wäre es je möglich, das Gerede sichtbar machen; die Kamera hat nur registriert, wie sich die Zuhörerinnen und Zuhörer während der Rede verhalten haben. Man könnte von einer behavioristischen Studie sprechen, vorausgesetzt dass vorgegeben wäre, wonach zu suchen sei. Gerade das aber ist nicht der Fall, so dass offen bleibt, ob die innere Anteilnahme des Publikums an der Rede überhaupt an die Oberfläche der Abbildung gelangt.

Im wahrsten Sinne des Wortes noch offenkundiger und zugleich rätselhafter sind die Aufnahmen aus den Büros von Helmut Friedel und Kasper König. Ein Jahr lang stand die Kamera mit geöffnetem Visier vor den Arbeitstischen der Direktoren, um aufzuzeichnen, was dort vor sich ging. Doch der im Ergebnis gläsern transparente Gesamteindruck wäre für den Betrachter relativ bedeutungslos, wenn die Bildlegende ihm nicht helfen würde, das Bild zu lokalisieren und inhaltlich aufzuladen. Hier wird eine Betriebsamkeit dokumentiert, die der Kunstvermittlung dient. Obwohl die körperliche Anwesenheit der Betreffenden nur einen schwachen Hauch hinterlassen hat, sind die Bilder durch und durch von dem Hin und Her der menschlichen Beschäftigung erfüllt. Da sind Möbel gerückt und verschoben worden, Bücher wurden gebraucht und für einige Zeit abgelegt, Papiere gerollt oder auf den Boden geworfen, Ordnungen geschaffen und wieder verändert worden. So ist es gewesen, steht den Bildern eingeschrieben, doch das rezipierende Subjekt kann die Rezeption der Kamera nicht nachholen. Was einmal war, ist verstummt, während die Deutlichkeit des trotzdem Sichtbaren die relative Unbeweglichkeit der Dinge wiedergibt, die während der Abwesenheit ihrer Benutzer nicht gebraucht wurden. Jede der fünf hier vorgelegten Schwarzweiß-Motive wird in der Bildlegende als Detail ausgewiesen, als Ausschnitt, so darf man hinzufügen, aus einem älteren, ursprünglich als Raumaufnahme konzipierten Bild. Mit solcher Hervorhebung verbindet Wesely offensichtlich den Versuch einer Konzentration auf ein Bild, das zwar in der Raumaufnahme schon enthalten ist, aber doch ebenso gut für sich betrachtet und dadurch vielleicht intensiver zur Geltung gebracht werden kann. Nebenbei gibt er durch die Reduktion der Gesamtansicht zu verstehen, dass er nicht als Spezialist für Interieurs auftritt. Neben diesen älteren sind auch mehrere der neueren Bilder der Vergrößerung von Details zu verdanken, darunter sicherlich etliche, die Wesely erst bei der Auswertung des entwickelten Filmmaterials aufgefallen sind. Dieses Hervorheben und Nahebringen ausgewählter Ausschnitte spricht recht deutlich für den eingangs erwähnten Übergang vom distanziert Konzeptuellen zum Sinnlichen. Stärker als je zuvor arbeitet Wesely heute an der Medialität des fotografischen Bildes. Er geht bis an die Grenzen des Sichtbaren und möchte ansichtig machen, was es zu sehen gibt, gerade auch dann, wenn es sich uns entzieht. Er möchte wissen, hinter welchen Horizonten das Unsichtbare beginnt, welche Botschaften uns die Teleskopie des Timing sendet und wie belastbar der lichtempfindliche Empfänger ist. Und wäre denn vorstellbar, dass er unversehens in Balzacs visionäres Jenseits der allgegenwärtigen „flüchtigen Abbilder" eintauchte?

In diesem Zusammenhang spielt die Unschärfe der Abbildung eine entscheidende Rolle. Die Bezeichnung „Unschärfe" unterstellt, dass der Betrachter sich eine schärfere Abbildung vorstellen kann, weil er zu wissen glaubt, wie der abgebildete Gegenstand aussieht.

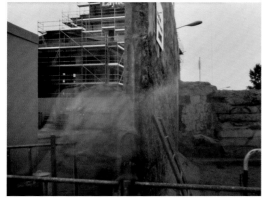

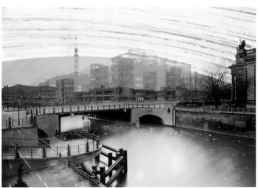

Das Brandenburger Tor
(14.25–14.35 Uhr, 12.5.1990)

Palast der Republik, Berlin
(28.8.2006–19.12.2008)

documented here is a certain industriousness serving the purpose of the dissemination of art. Although the physical presence of those concerned has only left a delicate trace behind, the images are brimful of the hustle and bustle of human activity. The furniture is repeatedly repositioned, books are picked up and then put down for a while, papers are rolled up or discarded onto the floor, and order is structured and restructured once more. The feeling of "this is how it was" is indelibly stamped on the images, and yet the receiving subject cannot emulate or recreate the camera's receptive acumen. What once was, has now fallen silent, whereas the clarity of those things that are still visible, recreates the relatively static dispensation of objects, which are self-evidently not utilised in the absence of their users. Each one of the black-and-white motifs presented here is identified as a detail in the respective title, as a section, one might add, of an older image originally conceived as a stereo photograph. By means of accentuations of this sort, Wesely is clearly linking an attempt at concentration with a specific image, which, although it is contained within the larger stereo image itself, could nevertheless be equally viewed on its own merits and thus come to the fore more intensively. Incidentally, the reduction of the overall view would indicate he is by no means a specialist for registering the look of interiors. Alongside these older photographs, several of his newer images are derived from the enlargements of details, among them a good number that only caught Wesely's attention when developing the films. This accentuation and bringing closer of selected sections serves to underline the transition mentioned at the outset, from a distanced, conceptual approach to a more sensual one.

Wesely is now working more intensely than ever before on the mediality of the photographic image. He travels to the very edge of the visible in order to highlight what there is to see, precisely in the very moment it eludes us. He would like to know the liminal properties of the invisible, what messages the metering of time sends out, and how resilient the photo-sensitive receptor might be. Could it be possible then that he might have inadvertently plunged into Balzac's visionary nether world of those omnipresent, "fleeting images"?

The blurred appearance of the image plays a decisive role in this context. The word "blurred" or the phrase "out of focus" imply that the viewer can envisage an image that is actually in focus and not blurred, because he believes he knows what the depicted object looks like. In so doing, he is reliant upon the static nature of the object, which confirms his supposition that photography fixes its object as reliably as he does. Deviations from the conventional norm are traced back to the possibility that either the camera or the depicted object might have inadvertently moved. However, if the eye, intent on fixing the object from an out-of-focus image, immediately infers the condition of the thing depicted, then the impression of something spectral, something altogether ghostly emerges. Someone like Balzac was intent on seeing phantoms in daguerreotypes, inasmuch as haptic qualities had been lost to photography to an even greater extent than to painting at that time. The staged absence of focus now appears all the more ready to offer a hint of something "inconceivable", in the truest sense of the word. To counter this somewhat naïve way of seeing, one might immediately argue that Wesely allows the viewer to look through specific temporal windows, duly informing him beforehand about the cause of the images' blurred appearance. It should be added that we have long since learned to recognise particular examples of out-of-focus imagery — determined by extended or repeated exposure — as the visual residues of temporally-determined processes. Anyone able to muster the necessary degree of attention can

Dabei verlässt er sich auf den statischen Charakter der Abbildung, der ihn in der Annahme bestätigt, dass die Fotografie ihren Gegenstand ebenso zuverlässig fixiere wie er selbst es zu tun vorgibt. Abweichungen von der konventionellen Norm werden darauf zurückgeführt, dass entweder die Kamera oder der abgebildete Gegenstand unversehens in Bewegung geraten war. Wenn aber der fixierende Blick sich verleiten lässt, von einer verschwommenen Abbildung unmittelbar auf die Beschaffenheit des Abgebildeten zu schließen, entsteht der Eindruck des Geisterhaften oder Gespenstischen. Schon jemand wie Balzac hatte in der Daguerreotypie Phantome der Dinge erblicken wollen, zumal den Lichtbildern das Haptische noch mehr abhanden gekommen war als ohnehin schon in der damaligen Malerei. Nun scheint sich die inszenierte Unschärfe erst recht als eine Andeutung von etwas im wahrsten Sinne des Wortes „Unbegreiflichen" anzubieten.

Gegen eine solche Betrachtungsweise, die ein gesundes Maß an Naivität mitbringt, kann man sogleich einwenden, dass Wesely den Betrachter durch genau bestimmte Zeitfenster blicken lässt und ihn so über die Ursache der Unschärfen seiner Bilder im Voraus informiert. Hinzu kommt, dass wir längst gelernt haben, bestimmte Unschärfen, die durch überdehnte oder wiederholte Belichtung bedingt sind, als visuelle Hinterlassenschaft zeitweiliger Vorgänge zu erkennen. Wer die nötige Aufmerksamkeit aufbringt, kann an den graduellen Unterschieden von Klarheit bis Unschärfe so etwas wie die Gestalt der Dauer des Abgebildeten ablesen.

Eine Blume steht zum Beispiel auch nach zweiundzwanzig Minuten noch gestochen scharf in ihrer Vase, während von den Menschen am Tisch umso weniger zu sehen ist, je häufiger sie währenddessen ihre Haltung verändert oder ihren Platz gewechselt haben. Wesely hat die Fotografie wie kein anderer um solche, manchmal extrem genutzte Möglichkeiten erweitert. Immer ist dann gleichzeitig zu sehen, was nach- und nebeneinander stattgefunden hat, vorausgesetzt, dass die Ereignisse nicht bis zur Unkenntlichkeit überblendet oder vom Hintergrund aufgesogen worden sind, denn gerade bei sehr ausgedehnten Langzeitaufnahmen sind gelegentlich Zeitcluster entstanden, die sich trotz der gegebenen Information kaum mehr entwirren lassen.

Man könnte sich hier mit dem Argument aus der Affäre ziehen, dass das Privileg der Kunst darin bestehe, uns Rätsel aufzugeben. Wenn man aber versucht, der Unschärfe auf den Grund zu gehen, stößt man auf Probleme, auf die schon Mark Gisbourne in einem bemerkenswerten Aufsatz unter dem Aspekt der Ontologie der Fotografie aufmerksam gemacht hat. Gisbourne erwägt eine Relation zwischen dem virtuellen Bild mit seiner Unmenge an erfassten Daten und den „grundlegenden strukturellen Einheiten des Nervensystems", den unendlich vielen „Neuronen" des Rezipienten. Er spricht in diesem Zusammenhang von einer „buchstäblich verkörperten oder verdoppelten Zeitwahrnehmung, die uns vor Augen geführt" werde.

An dieser Formulierung ist unschwer die bei Wesely praktizierte Paradoxie der statischen Erscheinung des Bewegten zu erkennen, die wiederum auf der ontologischen Diskrepanz von Zeit und Ding, beziehungsweise von Funktion und Substanz beruht. Sobald man von diesem Gedanken Gebrauch macht und dabei von der Zeitspur auf die Dingschiene wechselt, gewinnt das visu-elle Phänomen der Unschärfe an semantischer Prägnanz. So bedeutet ein Mangel an Sichtbarkeit auch einen Mangel an Gegenständlichkeit, sei es, dass der Gegenstand durch Bewegung an Kontur verloren hat oder dass er sich nur kurz hat blicken lassen. Selbst in der

perceive something akin to the substance of the depicted image's actual duration in the gradations, as they gradually move out of focus from initial clarity. Twenty minutes have elapsed and a flower is still in razor-sharp focus, whereas less can be seen of people at the table the more they move around, or change their posture, or their relative positions. Wesely has extended the remit of photography like no other in terms of such — occasionally extreme — possibilities. It is always possible to see the sequence of events, or indeed concurrent events, provided that the results haven't been exposed beyond all recognition, or have been absorbed into the background to a great extent, for occasionally time clusters emerge in the case of particularly long time-lapse images that can scarcely be unravelled despite the attendant information.

We might be able to get ourselves neatly off the hook here by arguing that the privilege of art resides in its duty to present us with puzzles. However, when one also tries to get to the bottom of the blurriness, one necessarily encounters problems, already voiced by Mark Gisbourne in a notable essay regarding the aspect of ontology in photography. Gisbourne ponders the relation between the virtual image with its mass of information and the "fundamental structural units of the nervous system", the infinite number of the recipient's "neurons". He writes in this context about a "literal embodiment or doubling of the perception of time, which is [brought before] our eyes". It is easily possible to recognise in this formulation the paradox, practised by Wesely, of the static appearance of moving entities, which conversely resides in the ontological discrepancy between time and object, that is to say, between function and substance. As soon as one makes use of this idea and switches from the time track to that of the object world, the visual phenomenon of blurred focus takes on pronounced semantic significance. In this way, a lack of visibility also means a lack of figurativeness, be it that the object has lost its contours due to movement, or that it could only be seen for a short time. Even in a blurred state, a residue of the "sender" is still apparent, so to speak. Thus, something that has long since vanished still appears to be present. What we experience in Michael Wesely's photographs is the presence of the absent in terms of its absence, or put differently, the transitory visibility of the long since invisible.

When time is stopped, the figurative is subject to the control of duration or the passage of time. It doesn't take much for us to imagine that objects forfeit their very substance in effect when exposed to other temporal circumstances. They remain objects only for as long as we are prepared to continue to treat them as such. Conversely, in certain circumstances we doubt their consistency if they only make a brief appearance. In this case it seems as though we have been deceived or presented with a falsehood. When we abandon a binding temporal frame of reference, which we do along with all objects when we are asleep, we duly give free rein to their protean manifestations in dreams. However, the camera doesn't sleep. Nor does Wesely photograph dreams, even if some of his photographs have wonderfully dreamlike qualities. The simultaneity of the sequential or intrinsically non-simultaneous granted him is due to a technical transmission manoeuvre that allows him to let reality present itself in whatever temporal condition it desires. When Balzac speaks of fleeting images that are forced to abide on the photosensitive plate, Wesely for his part does not simply summon up entities by virtue of their factual, momentary representation, but captures their sojourn, their transformation, their movement or their disappearance. In consequence, he is less concerned with creating the impression that things are what

Plates

Plates

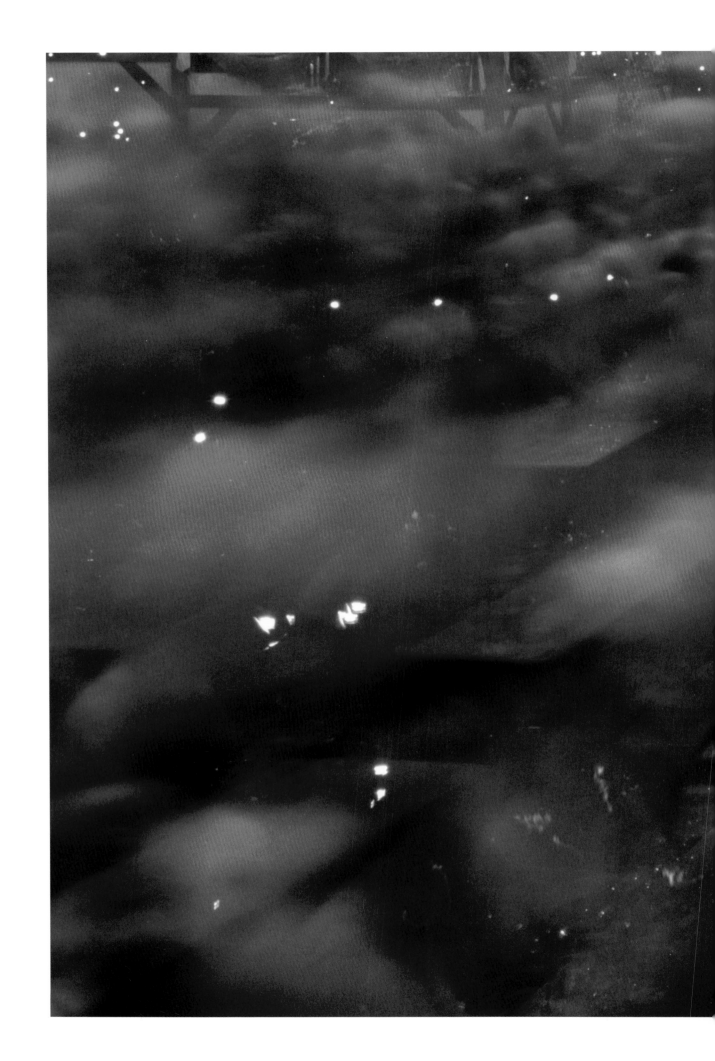

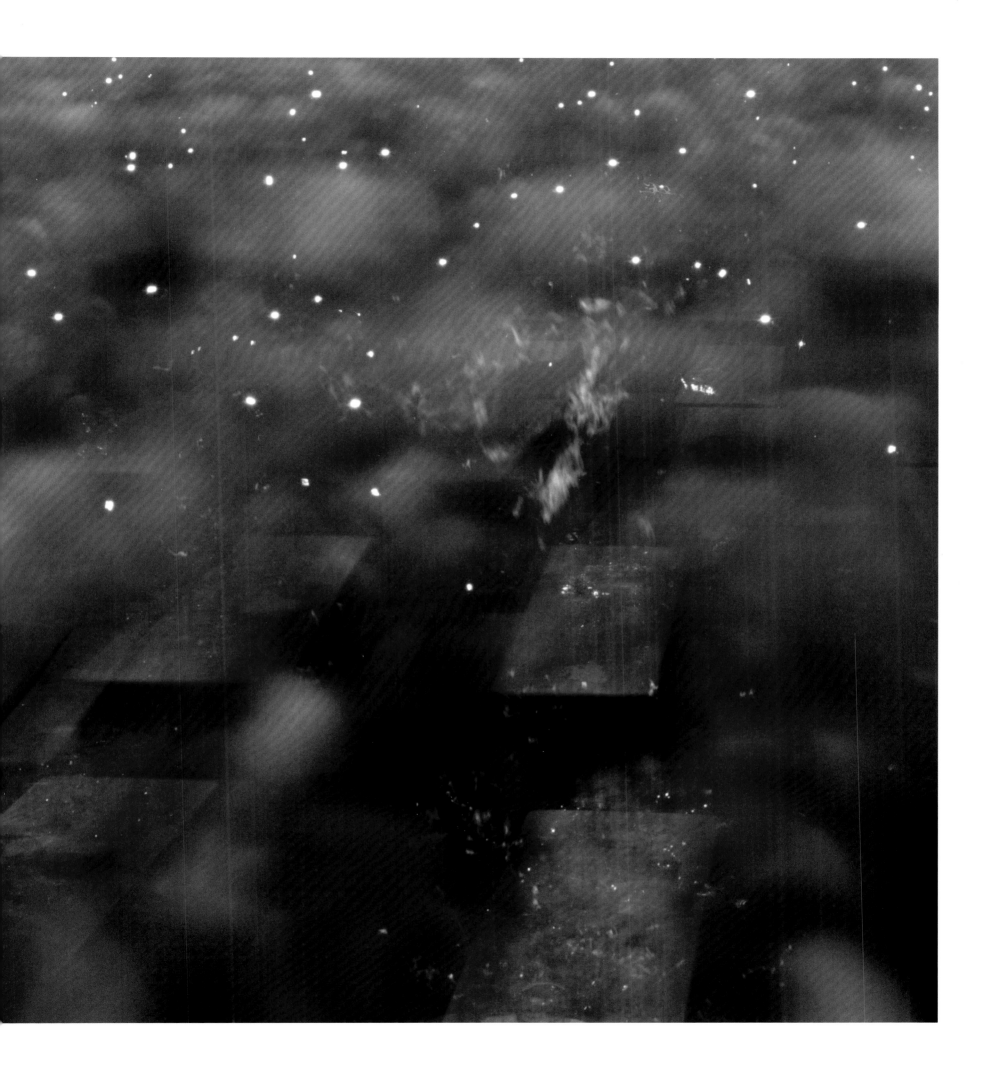

Löwenbräuzelt, Oktoberfest München (18.11–23.01 Uhr, 4.10.1996)

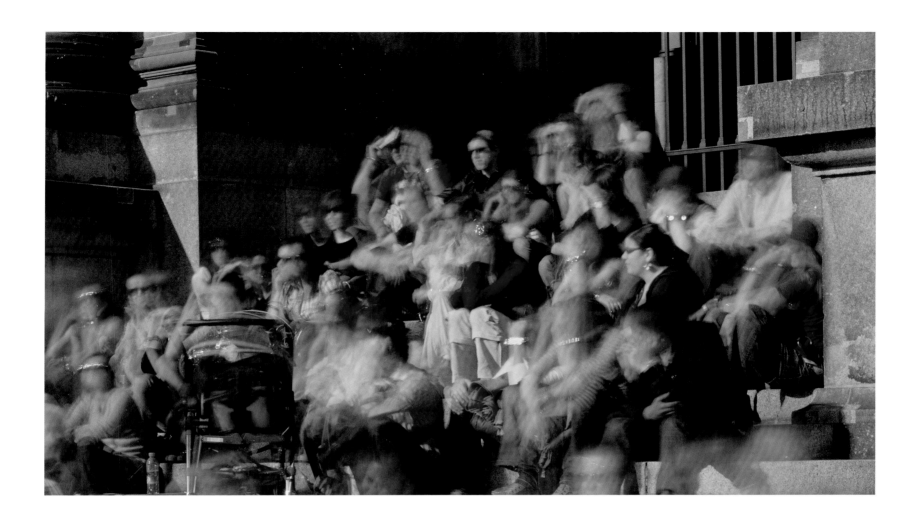

47

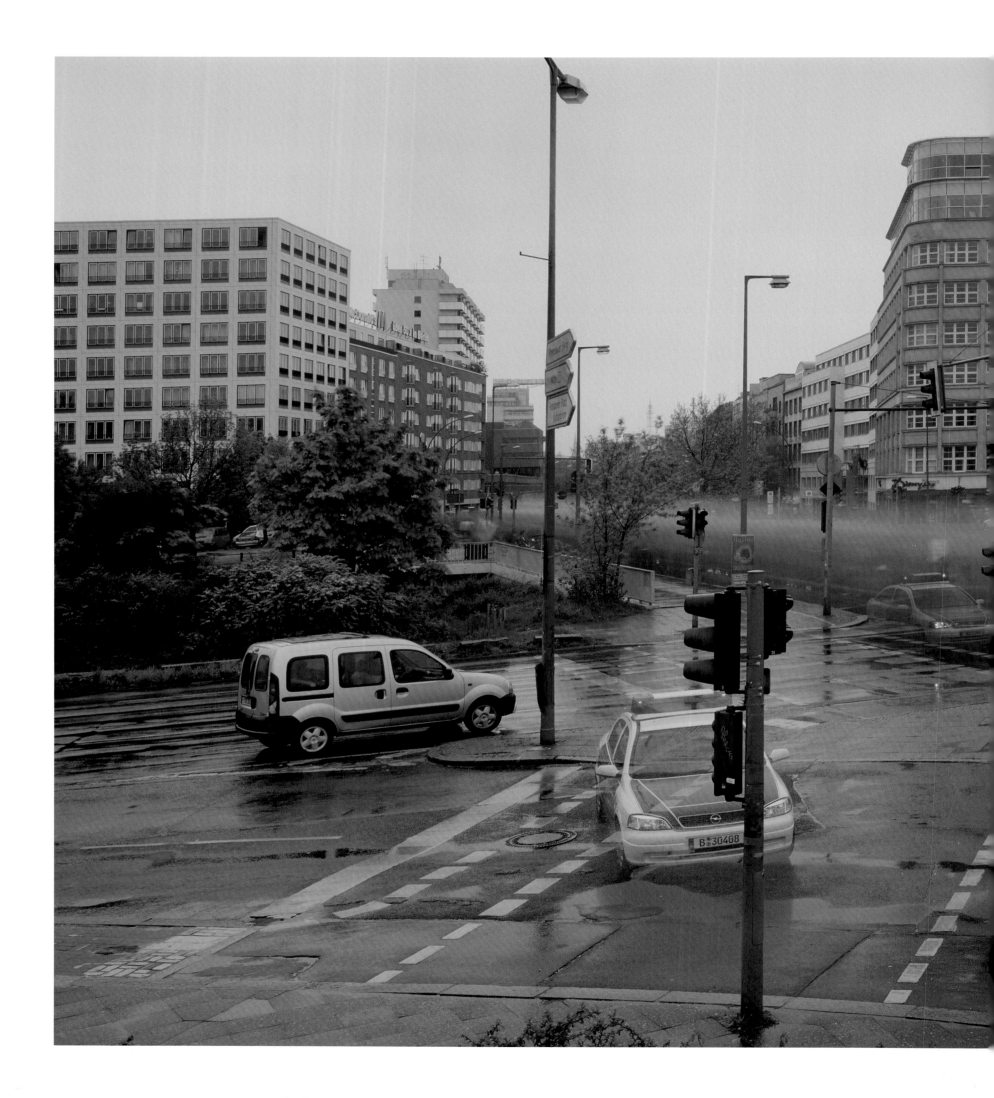

1. Mai-Demonstration, Potsdamer Straße, Berlin (10.03 – 10.08 Uhr, 1.5.2008)

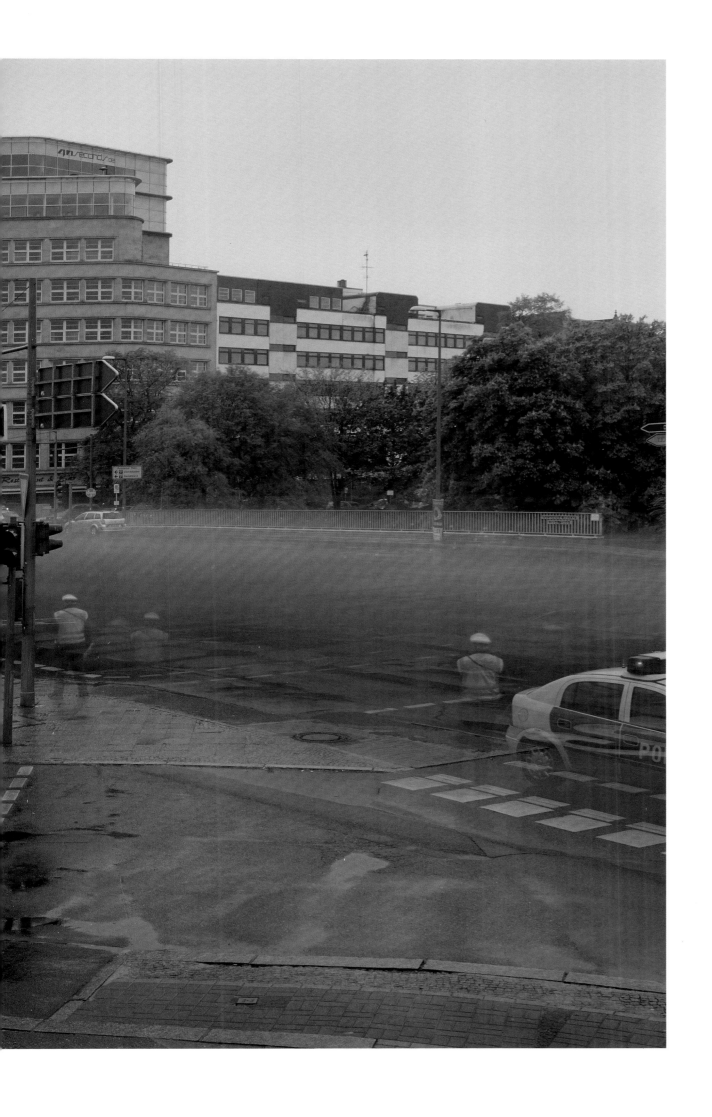

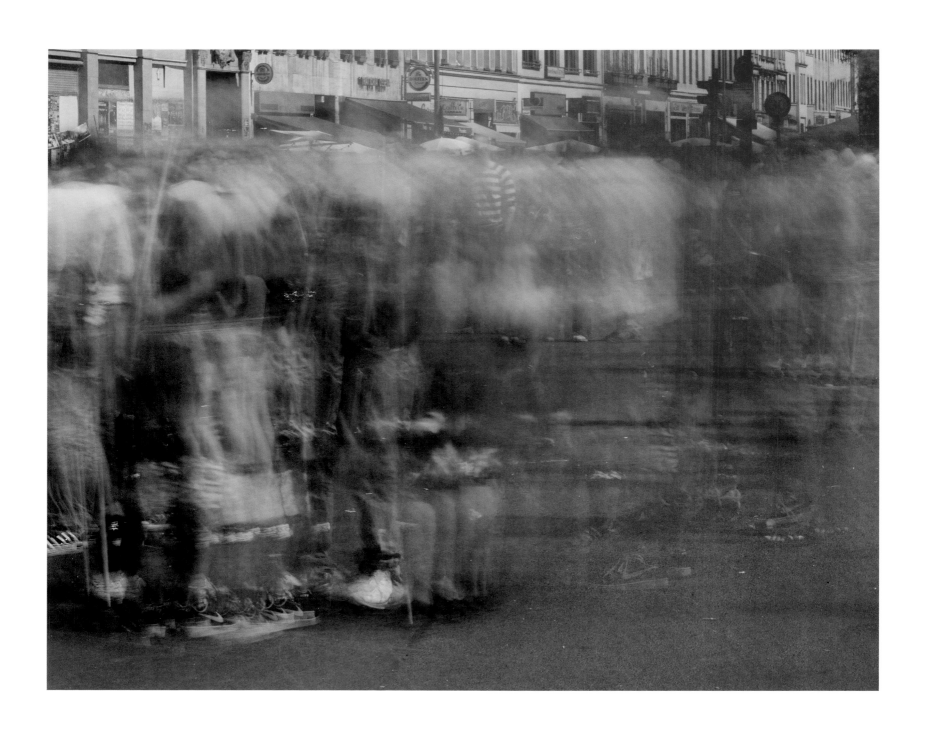

1. Mai-Demonstration, Oranienplatz, Berlin (14.00–14.05 Uhr, 1.5.2009)

51

61

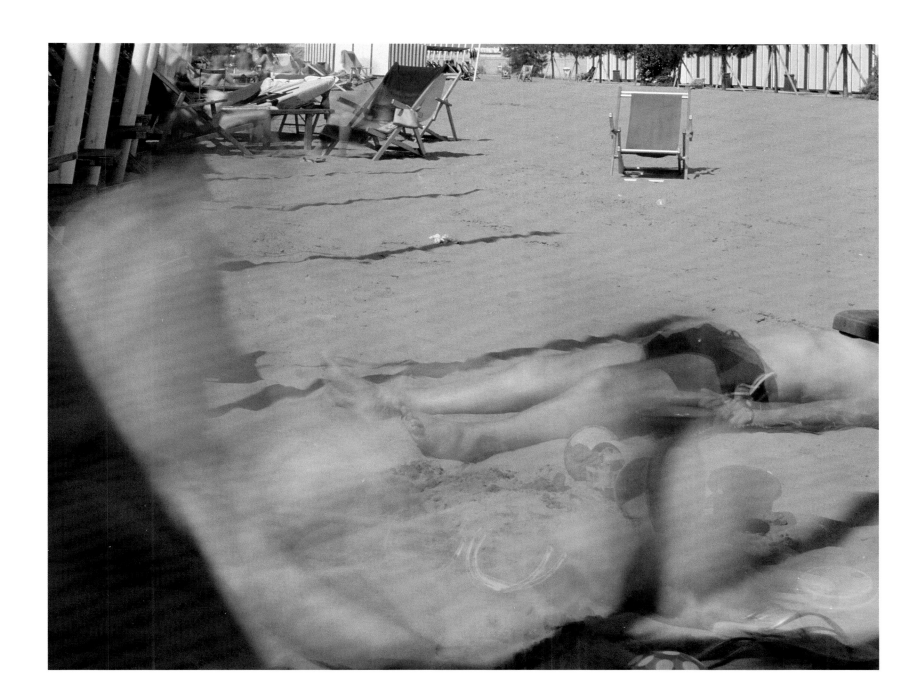

Lido di Venezia (16.16–16.21 Uhr, 3.6.2009)

65

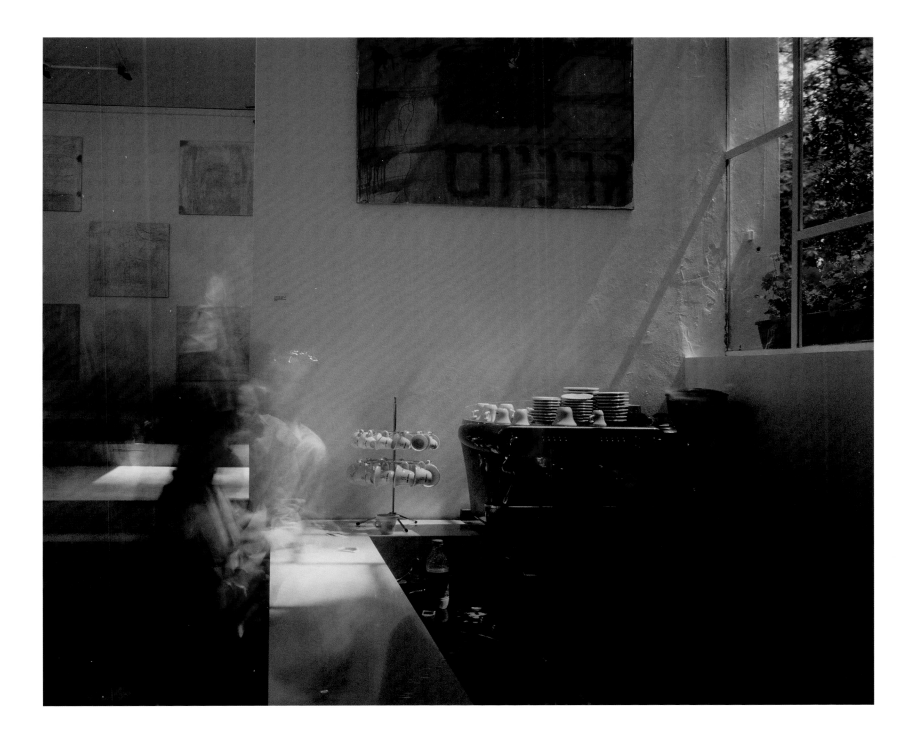

Pavilion of Israel, La Biennale di Venezia (12.07–12.12 Uhr 4.6.2009)

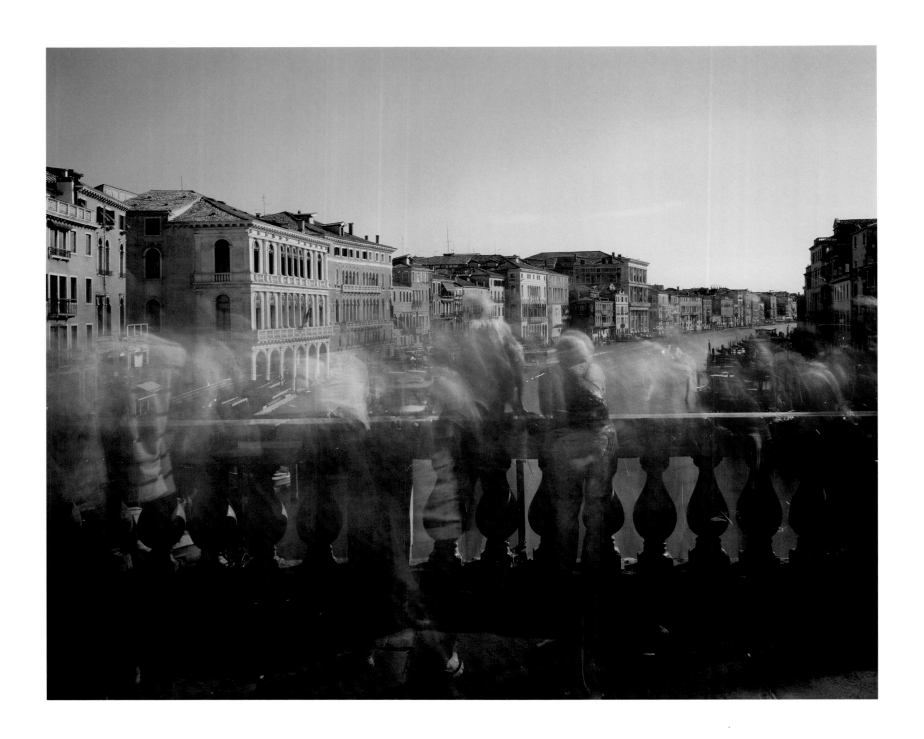

Ponte di Rialto, Venezia (17.40–17.45 Uhr, 2.6.2009)

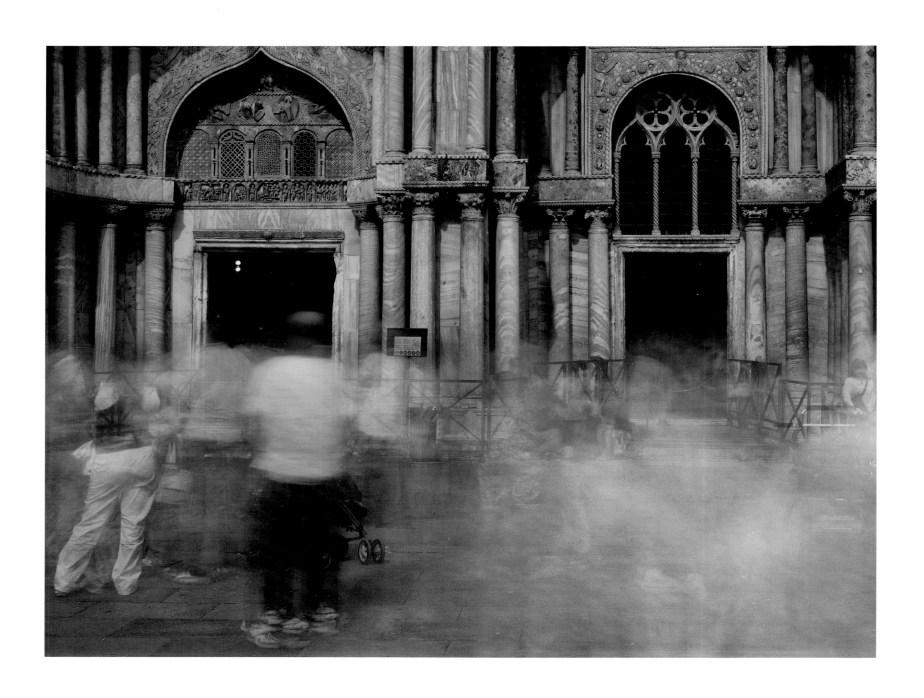

Palazzo Ducale, Venezia (16.24 – 16.29 Uhr, 1.6.2009)

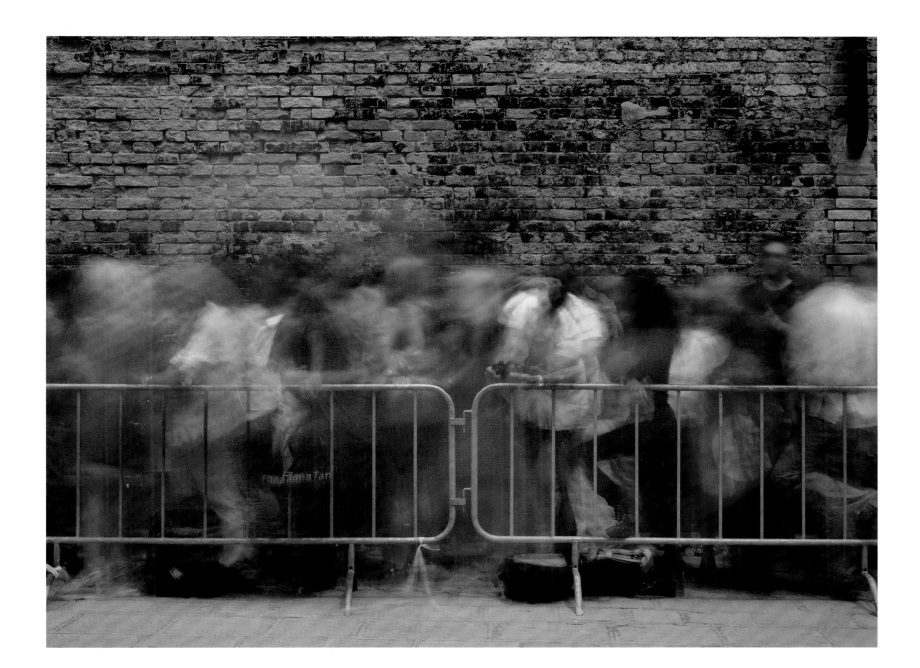

Arsenale, La Biennale di Venezia (12.36–12.41 Uhr, 6.6.2009)

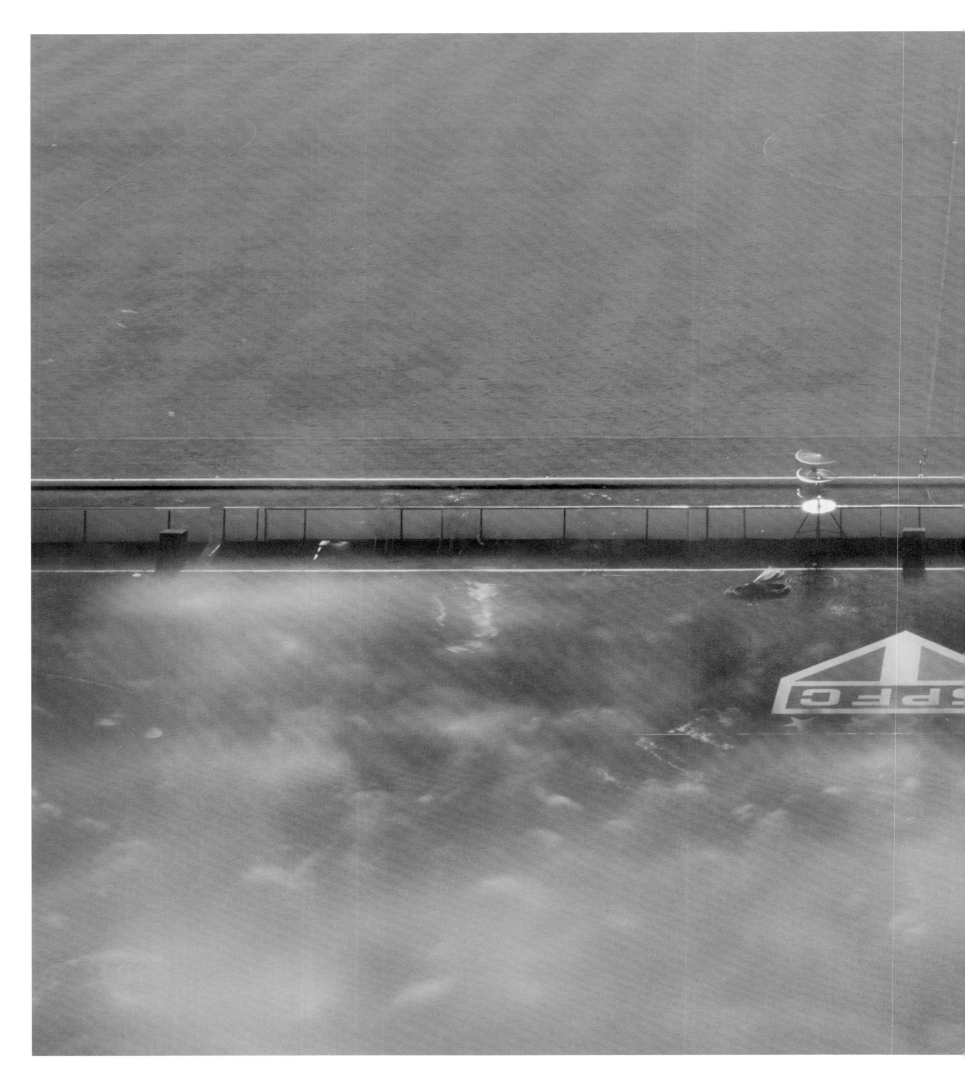

Corinthians FC – AA Ponte Preta (15.00 – 16.53 Uhr, 27.11.2005)

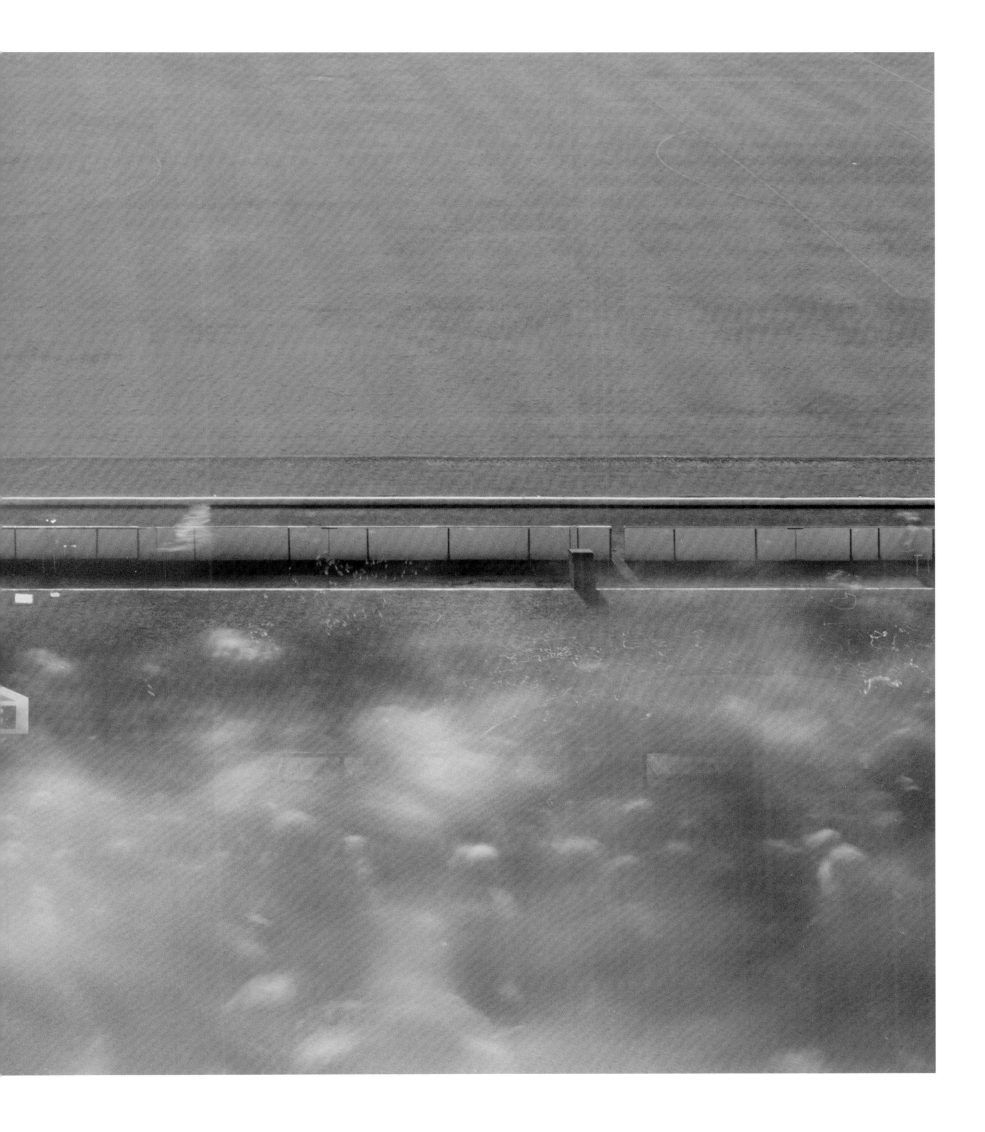

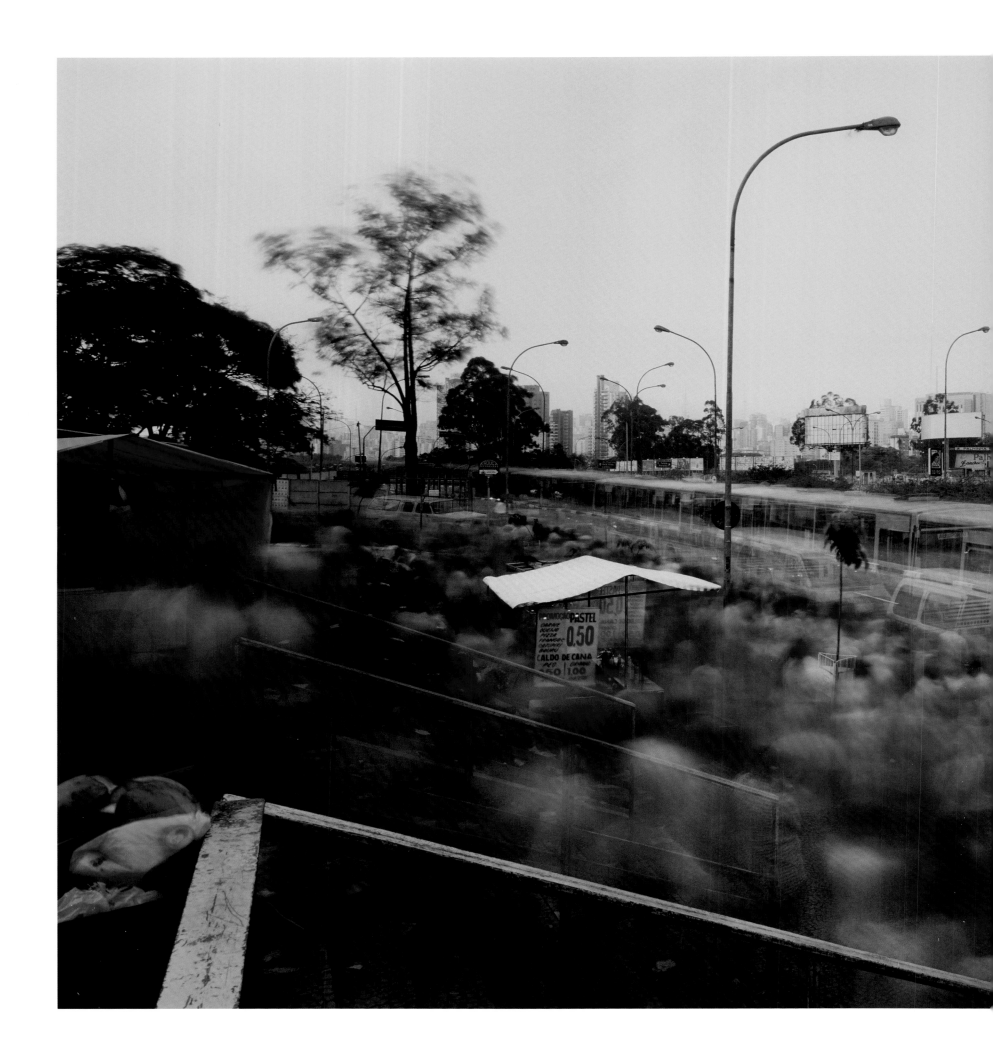

Ponto de Ônibus, Parque do Ibirapuera, São Paulo (16.26 – 16.46 Uhr, 12.10. 2001)

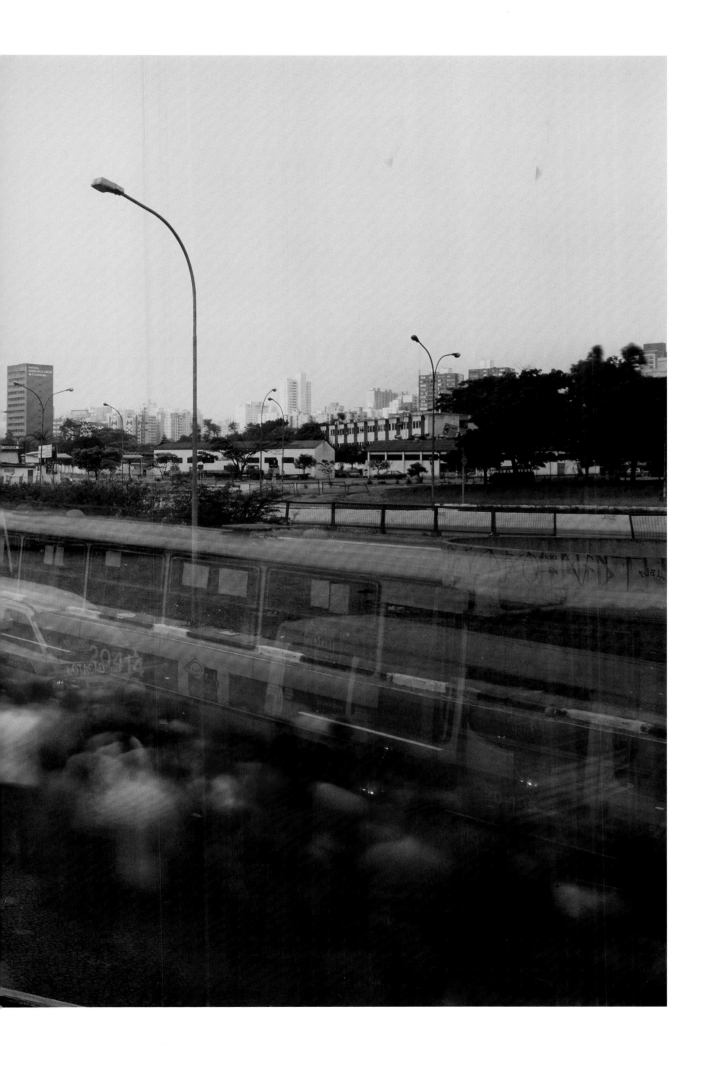

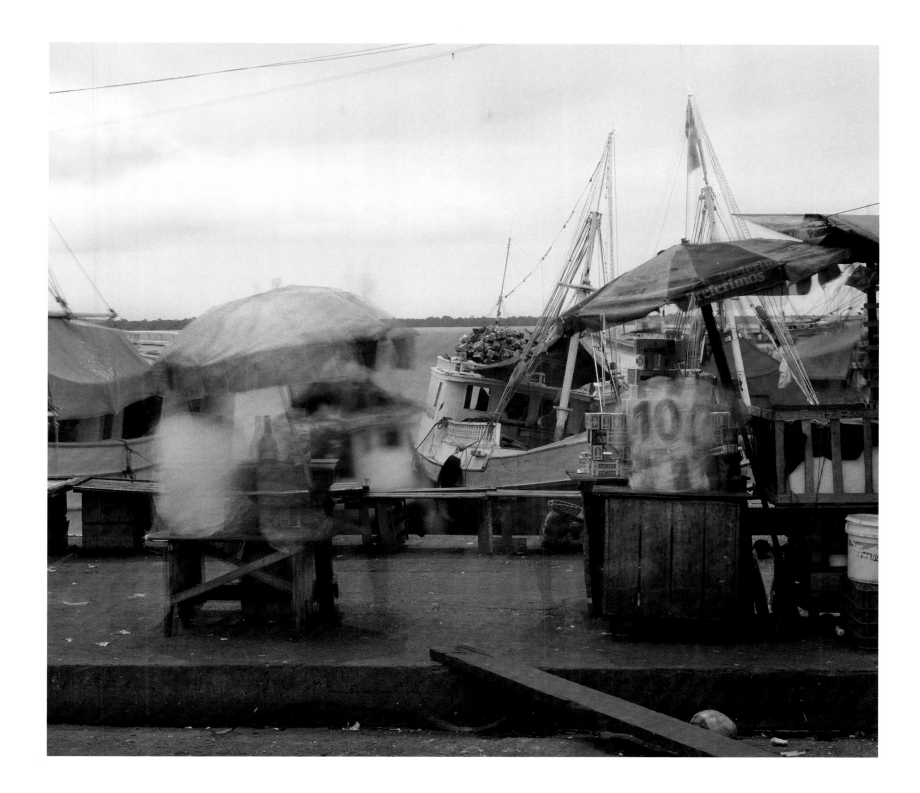

Porto Velho, Belém (12.21–12.31 Uhr, 4.8.2003)

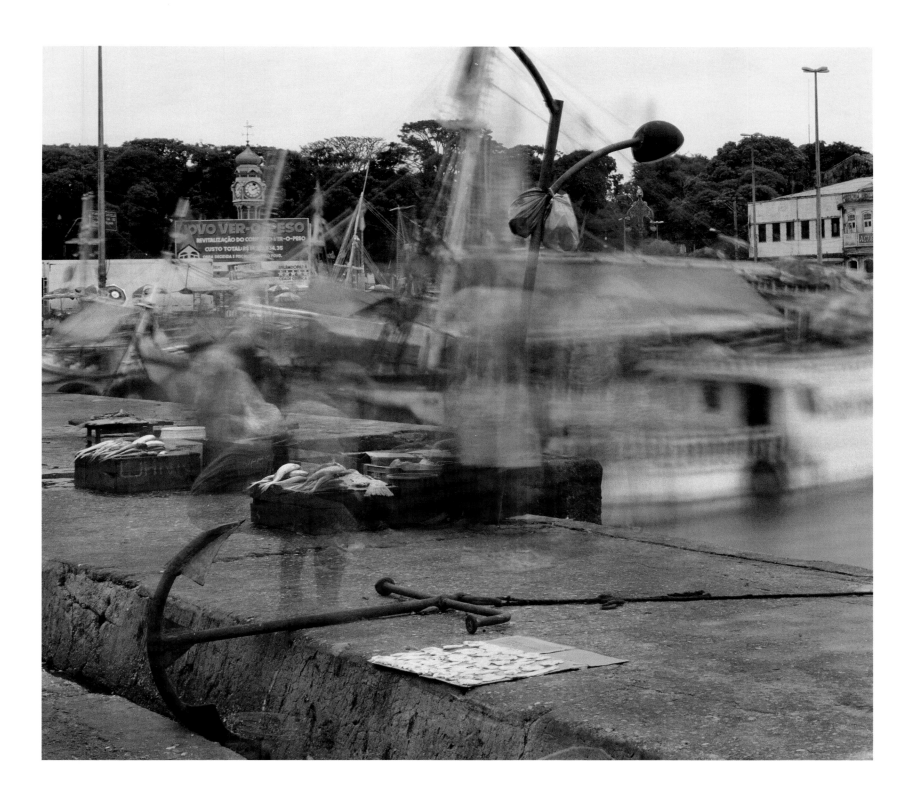

Porto Velho, Belém (13.45 – 13.55 Uhr, 4.8.2003)

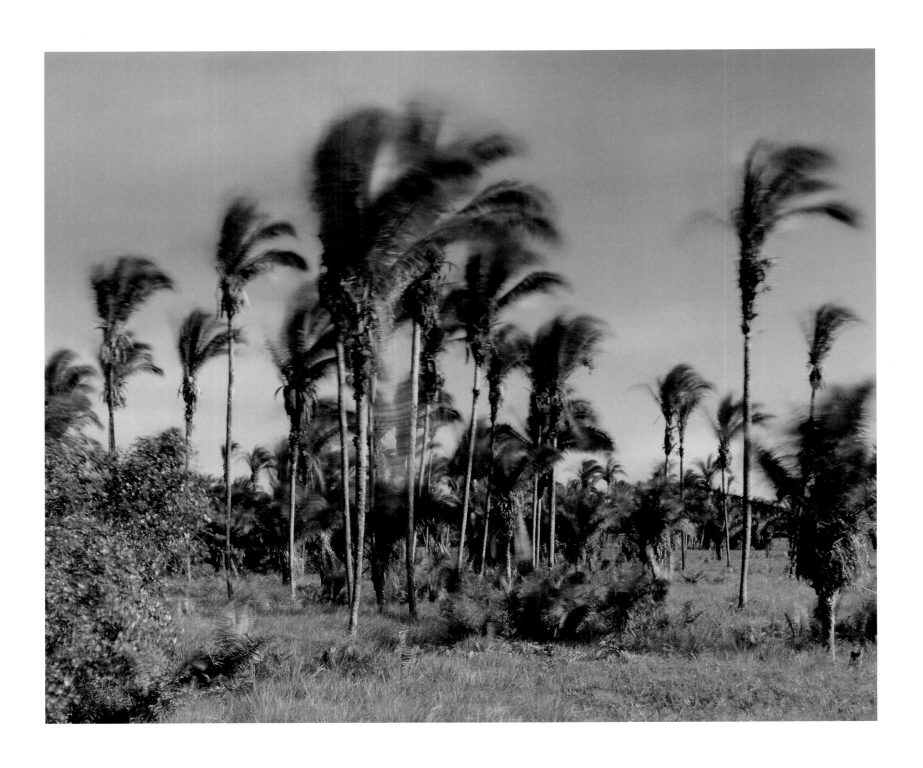

km 131, Palmeiras, Marana (14.45–14.55 Uhr, 6.8.2003)

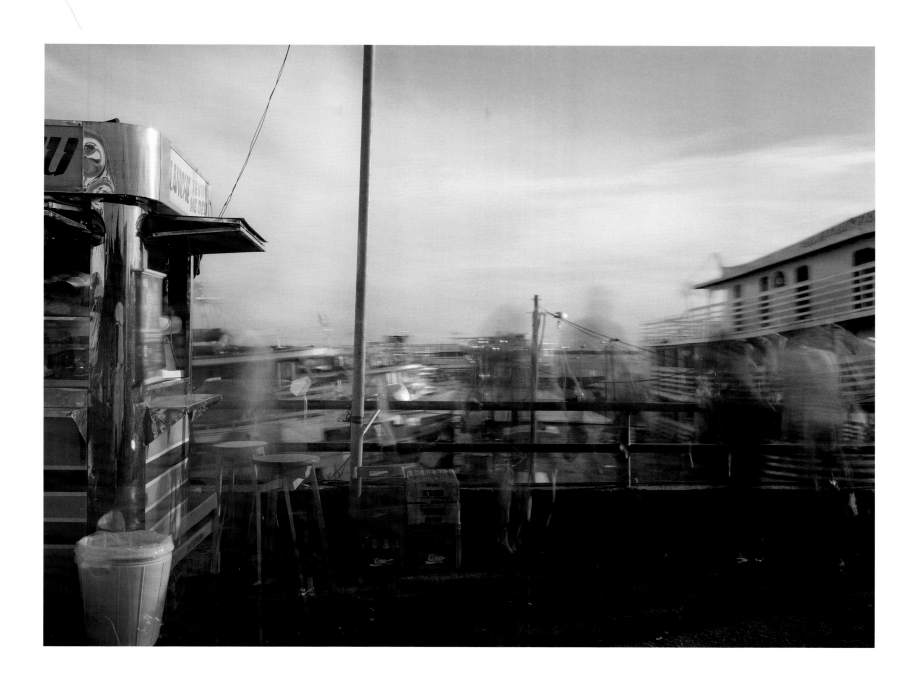

Porto de Manaus (16.44 – 16.54 Uhr, 28.7.2003)

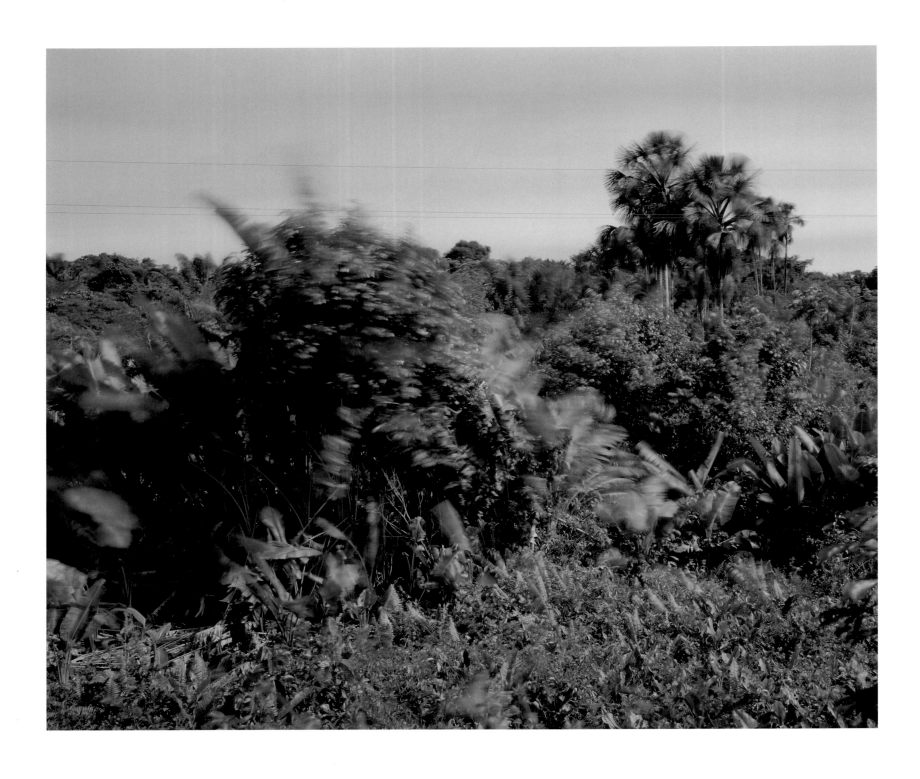

Bananal, BR 316, Brasil (8.25–8.35 Uhr, 6.8.2003)

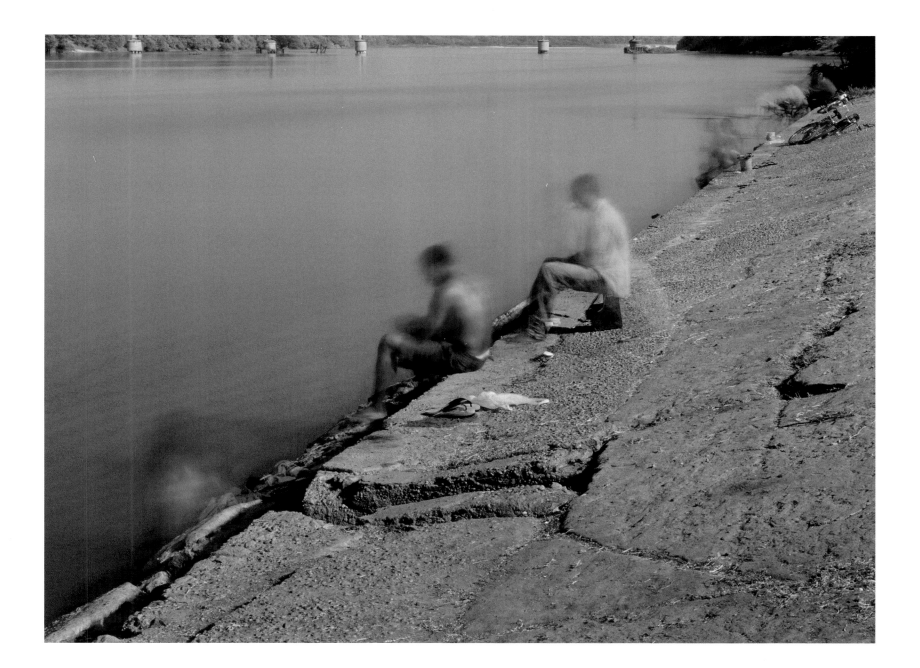

Rio Parnaíba, Teresina (7.11 – 7.21 Uhr, 15.8.2003)

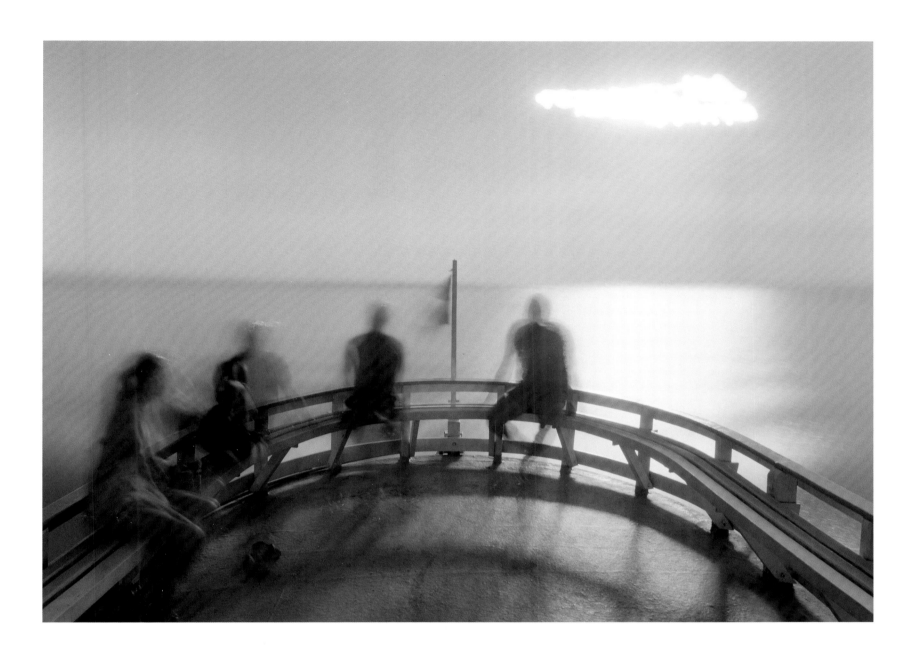

Rio Amazonas, Brazil (16.57–17.07 Uhr, 27.7.2003)

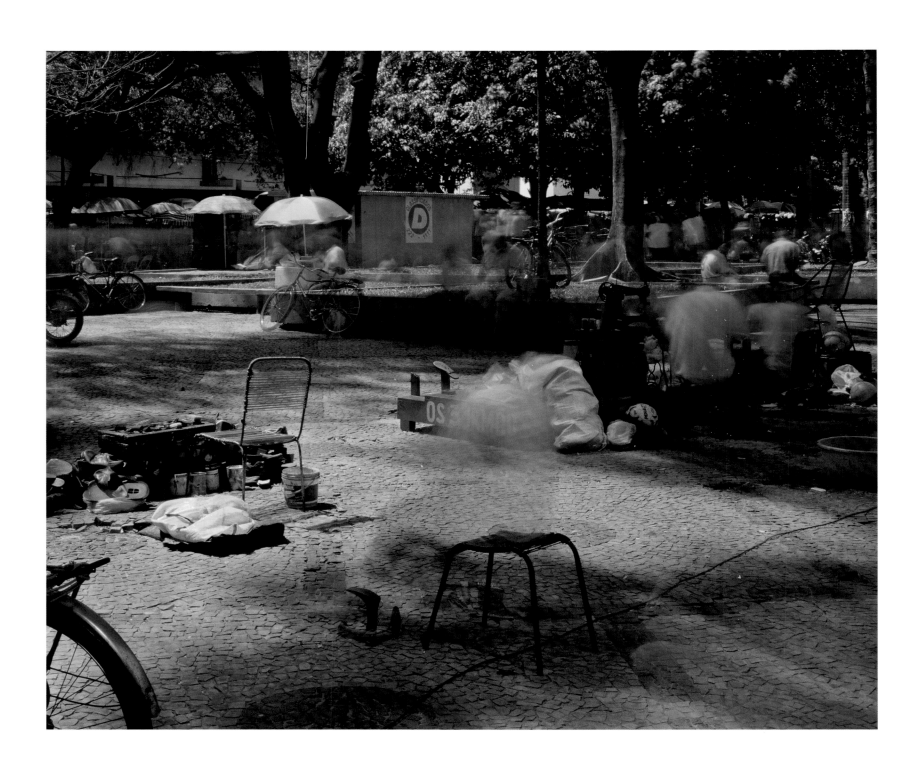

Centro, Teresina, Brasil (9.26 – 9.36 Uhr, 15.8.2003)

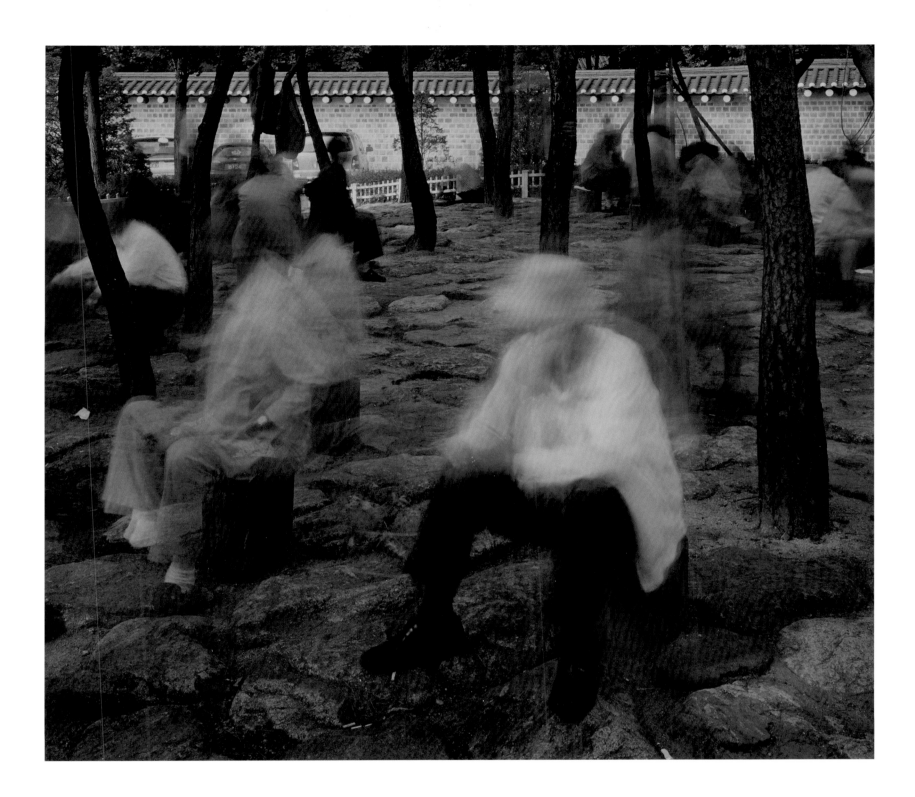

Veteran's Park, Seoul (15.14 – 15.19 Uhr, 20.9.2005)

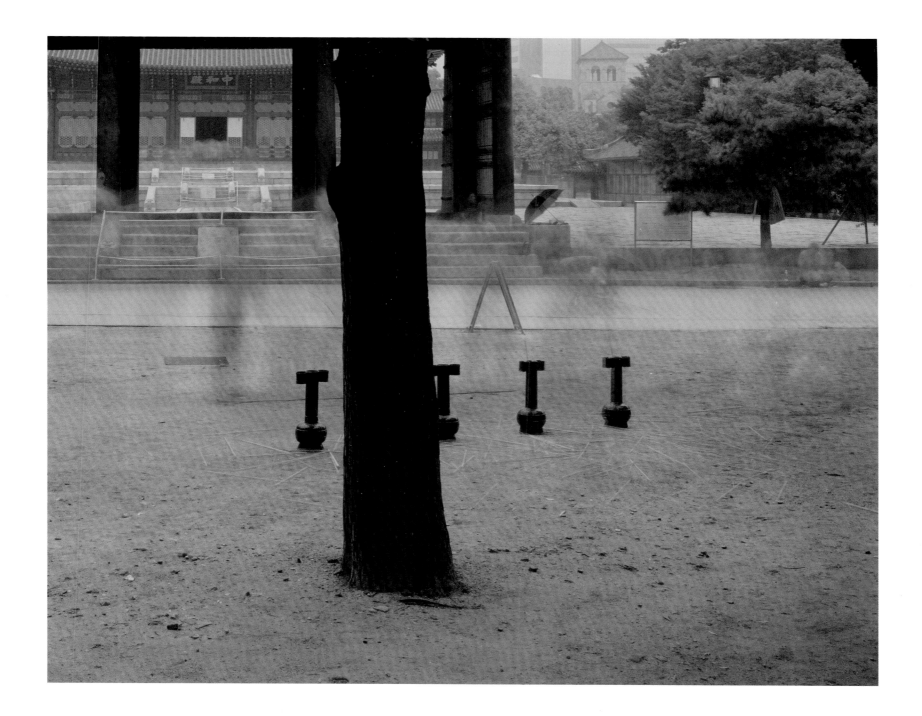

Deoksugung Palace, Seoul (16.32 – 16.37 Uhr, 18.9.2005)

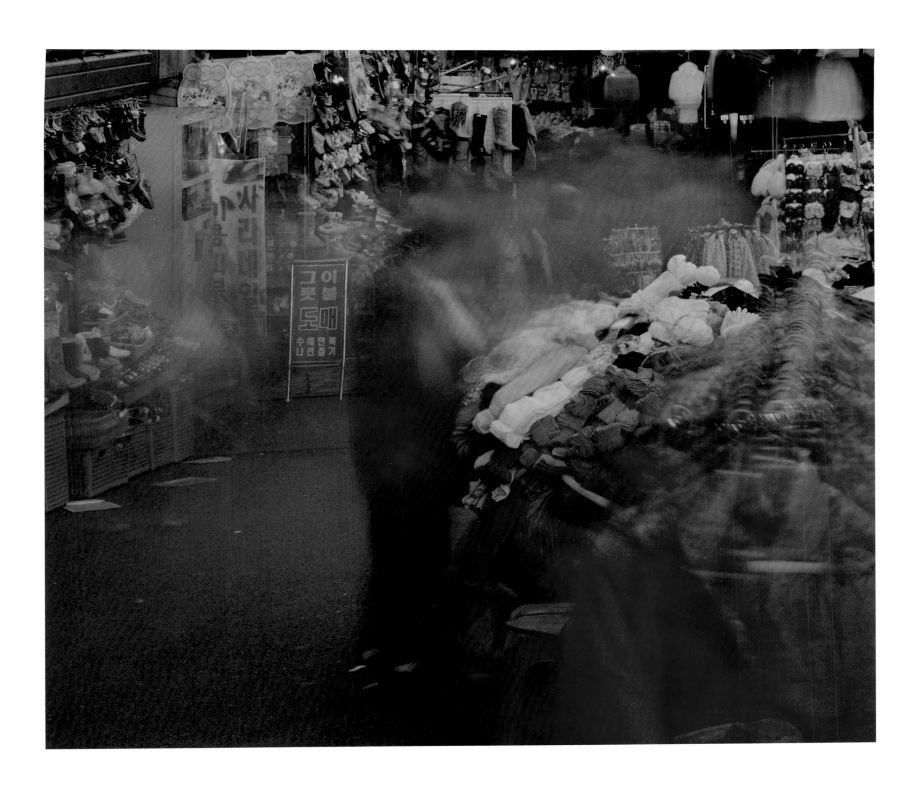

Nam Dae Moon Market, Seoul (11.16–11.26 Uhr, 8.11.2005)

107

Michael Wesely
1963 in München geboren / born in Munich
lebt und arbeitet in Berlin / lives and works in Berlin

Gruppenausstellungen / Group Exhibitions
Auswahl / Selection
Katalog / Catalogue (K)

2010 *Time Works* Galerie Nusser & Baumgart, München (K)
2007 *Works 2000–2006* Julie M. Gallery, Tel Aviv
Still Life 2001–2004 Galeria Baró Cruz, São Paulo, Brazil
Still Life 2001–2004 The Columns, Seoul
Men and Places. Chandigarh (mit Lina Kim), Galeria Blanca Soto, Madrid
Stilleben 2001–2004 Gemeentemuseum, Den Haag (K)
2006 *Encounter with Caspar David Friedrich* Alte Nationalgalerie Berlin (K)
Open Shutter Fahnemann Projects, Berlin
Collected Landscape The Columns, Seoul
2005 *Die Erfindung des Unsichtbaren* Guardini Galerie, Berlin,
Fotohof, Salzburg (K)
Arquivo Brasília (mit Lina Kim), Teatro Nacional, Brasília, Brasilien
2004 *Open Shutter Project* Museum of Modern Art, New York (K)
Ostdeutsche Landschaften Fahnemann Projects, Berlin (K)
2003 *Camera d'arte – ordine del giorno* Galica Arte Contemporanea, Mailand (K)
Iconografias Metropolitanas Fahnemann Projects, Berlin
Kleiner Ausflug Kunstverein Rosenheim (K)
2001 *American Landscapes* Galerie Fahnemann, Berlin
2000 *Paesaggi Americani* Galleria Primo Piano, Rom
American Landscape Museum Schloss Moyland (K)
Potsdamer Platz, Berlin 1997–1999 Haus Huth, Berlin (K)
1999 *PHE99* Galeria Metta, Madrid

Einzelausstellungen / Solo Exhibitions
Auswahl / Selection
Katalog / Catalogue (K)

2010 *Summer loves* Huis Marseille, Amsterdam
Entretiempos Teatro Fernan-Gomez Arts Center, PHotoEspaña 2010,
Madrid (K)
2009 *Everyday Ideologies* Kunstmuseum Magdeburg (K)
Berlin 89/09 Kunst zwischen Spurensuche und Utopie
Berlinische Galerie, Berlin (K)
Retratos de Nueva York: Fotografias del MoMA La Casa Encendida,
Madrid (K)
2008 *Stille Landschaften* Städtischen Galerie Lüdenscheid (K)
Michael Wesely & L'anverre The Columns, Seoul
2007 *Reality Crossings* (mit Lina Kim), 2. Fotofestival Mannheim (K)
2006 *Spectacular City* Netherlands Architecture Institute, Rotterdam (K)
Rohkunstbau XIII Groß Leuthen (K)
Die Schönheit der Chance Institut für Moderne Kunst, Nürnberg (K)
Futebol – Desenho sobre Fundo Verde CCBB, Rio de Janeiro (K)
herzog & de meuron no. 250 Haus der Kunst, München (K)
Metropolitanscape (mit Lina Kim), Palazzo Cavour, Turin (K)
Through the Looking Glass (mit Lina Kim), Haus der Kunst, München
Arquivo Brasília (mit Lina Kim), 9th Havana Biennale, Cuba (K)
2005 *After the Facts* Martin-Gropius-Bau, Berlin (K)
Focus Istanbul Martin-Gropius-Bau, Berlin (K)
Berliner Zimmer Nationalgalerie – Hamburger Bahnhof, Berlin
2004 *Coletiva* Galeria Baró Cruz, São Paulo, Brazil
2003 4th Mercosul Biennial Porto Alegre, Brazil (K)
Interrogare il luogo Studio la Città, Verona (K)
2002 *Europe – America* Selection from the 25th Biennale of São Paulo
Museo de Arte Contemporaneo, Santiago, Chile (K)
25th Biennial of São Paulo (K)
Brasília: Ruine und Utopie Brasília, Brasilien (K)
2001 *2115 km* Museum für Moderne Kunst, Moskau (K)
2000 *Modern Starts: Places* Museum of Modern Art, New York (K)
1999 *Wohin kein Auge reicht* Deichtorhallen Hamburg (K)

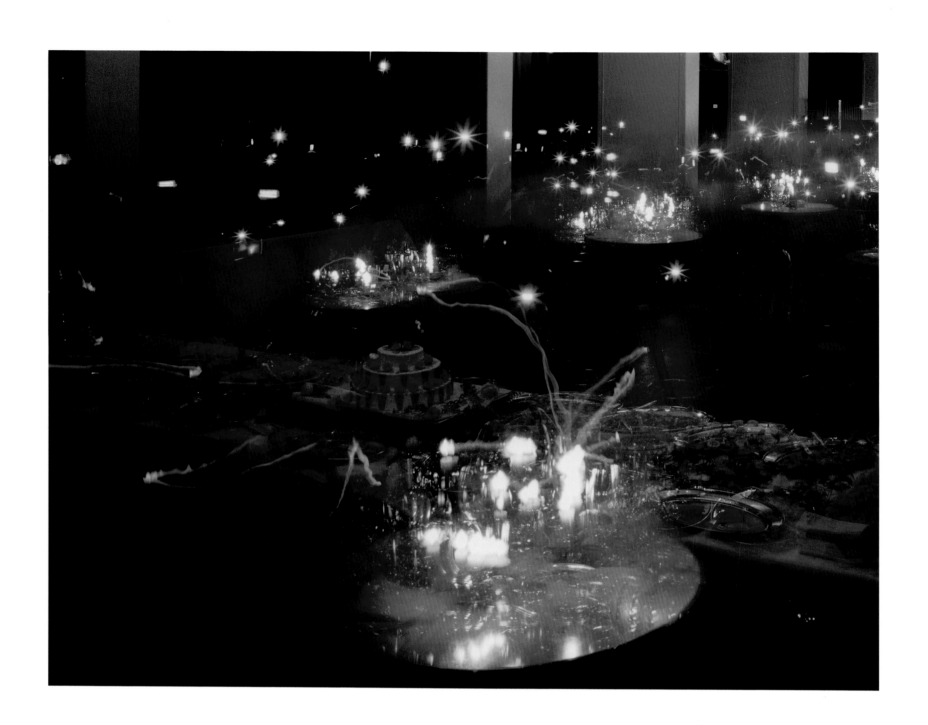

110

Grüner Salon, Volksbühne Berlin (20.00–23.40 Uhr, 10.6.2001)

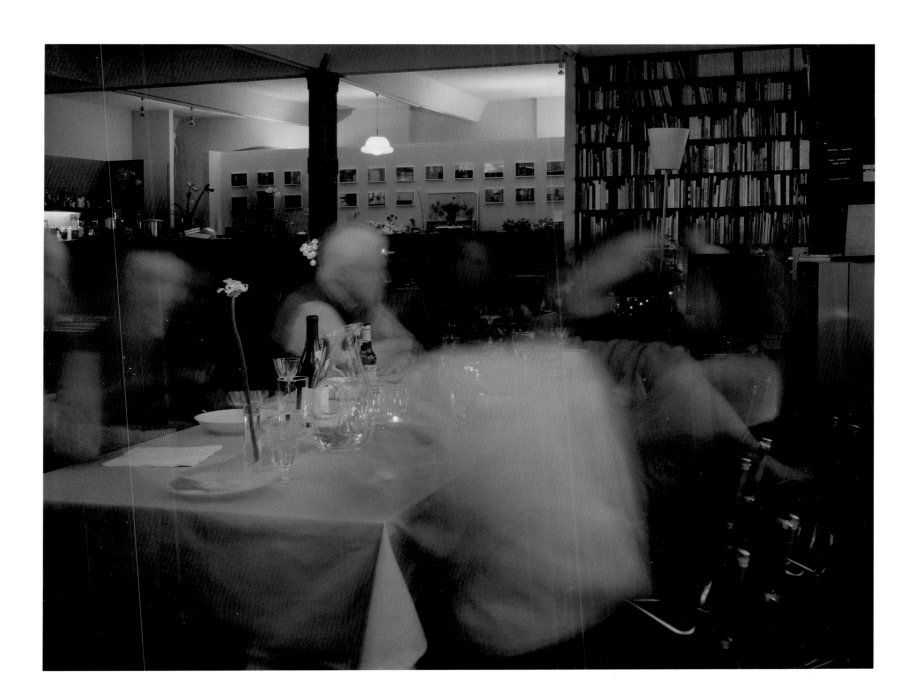

Sonntagsessen (16.23 – 16.45 Uhr, 30.11.2008)

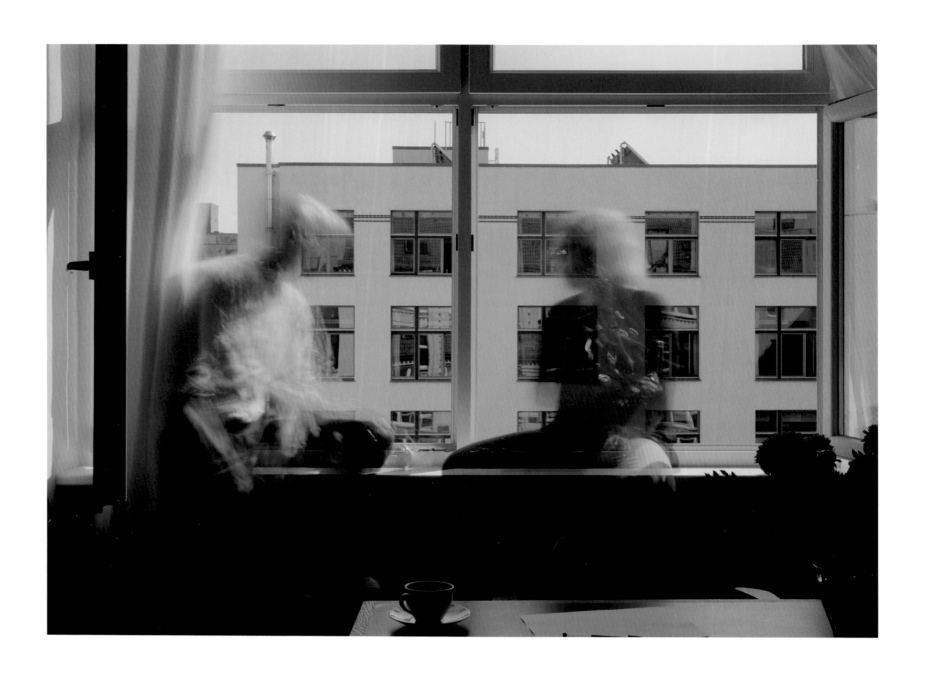

Robert und Kerstin, Zigarettenpause (10.52 – 10.57 Uhr, 10.8.2008)